2009

Collins
30 minute

People in Watercolour

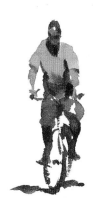

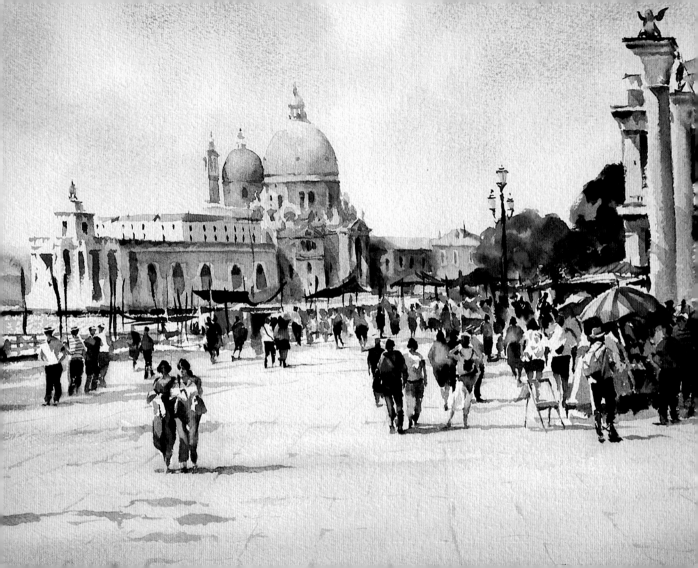

Collins
30 minute

People in Watercolour

Trevor Waugh

First published in 2009 by
Collins, an imprint of
HarperCollins*Publishers*
77-85 Fulham Palace Road
Hammersmith, London W6 8JB

www.collins.co.uk

Collins is a registered trademark of HarperCollins Publishers Limited.

13 12 11 10 09 08
7 6 5 4 3 2 1

A catalogue record for this book is available from the British Library.

Editor: Diana Vowles
Designer: Kathryn Gammon

ISBN 978 0 00 728489 4

Colour reproduction by Colourscan, Singapore
Printed in China

About the Author

Trevor Waugh was born in London and studied at the Slade School of Fine Art under the tutelage of Sir William Coldstream, Patrick George and David Hockney. Now based in Cheltenham, he exhibits and teaches all over the world. He is a founding member of the New Orientalists group based in the Middle East and his paintings appear in royal collections in the Emirates. He is a regular contributor to *The Artist* magazine and gives demonstrations to art societies worldwide. His paintings can be seen on a variety of greetings cards and art products. This is his fifth book for HarperCollins. For more information see www.trevorwaugh.com.

Dedication
For all my students wherever you may be. Hopefully this book will help you.

Acknowledgements
My thanks go to Cathy Gosling, Kathryn Gammon and all the team at
HarperCollins for their support and encouragement with this project. To
Diana Vowles, for her superb editing skills as always. Thanks also to Steve
and Laki Boyer for *Beach Tango* and Helen for *Snow at Crickley Hill*.
Thanks to Tim Stubbs for the photograph. Lastly to Darlas for being there,
you are truly special.

**Essex County
Council Libraries**

CONTENTS

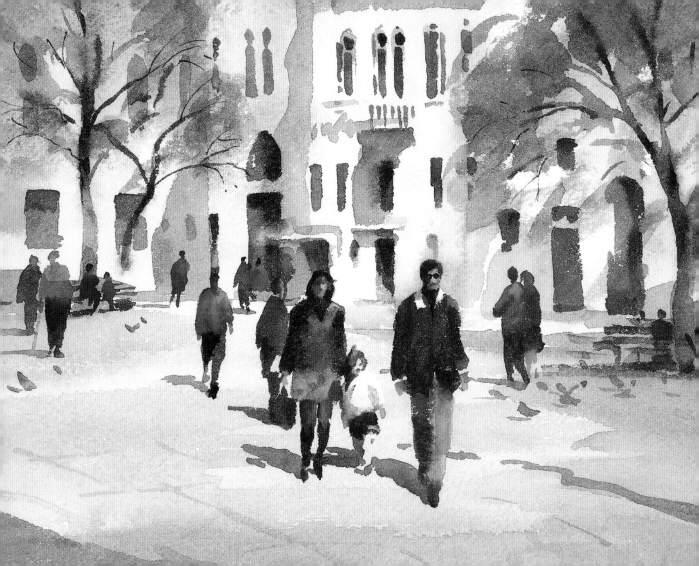

INTRODUCTION

For me, watercolour is the most spontaneous and suggestive medium, and I find the whole process of painting with it an exciting journey of discovery about both the subject and myself.

Unfortunately, there are many disheartening myths about watercolour – for example, that you have to get it 'right' first time because you can't make corrections, and that painting people in this medium is harder to do than any other subject. I hope I can dispel some of these misconceptions in this book and encourage you to have a go at painting people with pleasure and fluency, enjoying the freedom and excitement that watercolour offers.

◀ **People in the Campo**
18 × 25.5 cm (7 × 10 in)
This painting is a good example of a limited palette in operation, making as much use of light and dark as possible. Only six colours were used, mostly blues and browns.

People in watercolour

It is true to say that if you can't draw it you can't paint it, so attention to your drawing skills is essential and the key to finding out how to describe people in paint. A short time spent doing some simple line drawing will help you to get your eye in before you pick up your brush. Quick sketches, taking only five or ten minutes, can also help to loosen you up and take away any anxiety about making the first marks on paper.

Look for the basic shapes of the human form and their relative sizes to one another rather than details. When you start to paint, let the colours flow naturally together and don't try to force them; corrections can take place later on. Remember that watercolour is an accidental medium, so you need to respond to the way that the colours behave on the paper.

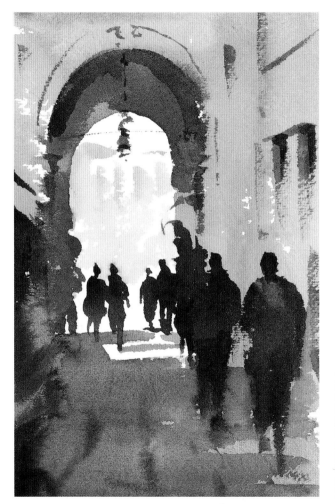

◀ **The Archway**
I painted the arch and street scene first, limiting my colours to just three – Raw Sienna, Cobalt Blue and Lamp Black. Finally I put in my people as silhouettes, using Lamp Black.

The aim of this book

Many artists find the human figure the most challenging subject to paint and watercolour the most daunting medium. However, my belief is that a simple approach and a step-by-step procedure will bring you rewarding results in a short space of time. Knowing what to look for in your subject and how to capture it is half the battle. If you can achieve success with simple things, this will give you the confidence to be more adventurous and stretch yourself further.

In this book you will find new ways of looking at this supposedly difficult subject, along with quick exercises and straightforward information to help you, paint people successfully. You will be surprised at how much you can achieve in a 30-minute painting and the joy it brings.

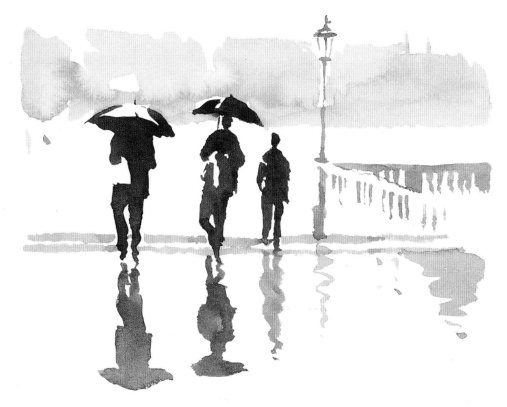

◄ **Umbrella People**
Using only Burnt Umber, I reduced my composition to just three tones. The white of the paper has been employed to do a lot of the work here.

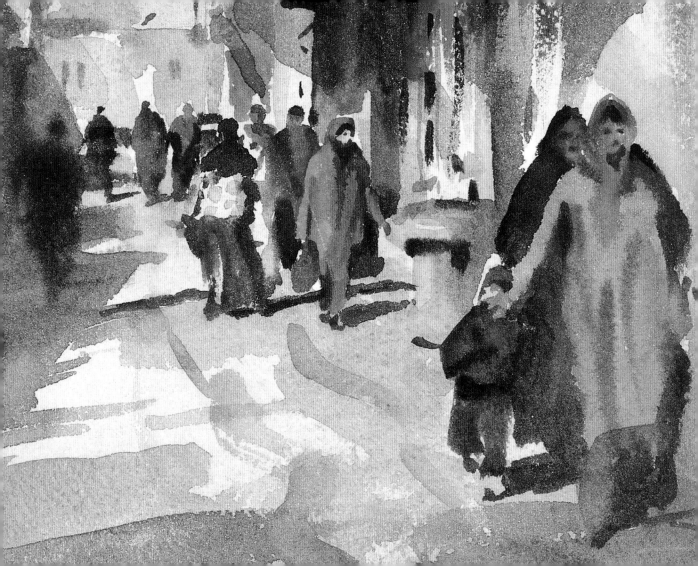

ESSENTIAL EQUIPMENT

Even for beginners in watercolour, good-quality artist's materials are imperative. They are more expensive but you will find that a little goes a long way, and the better results you will get compared to those from cheap materials will encourage you to keep on developing your skills.

There is a huge range of products to be found in the shops and mail order catalogues, and this can be bewildering, especially for novices. If your budget is limited, my advice is to purchase only top-quality paper, brushes and pigments, and leave items such as bags, pots, portfolios and brush-holders for another day.

◀ **Lady in Pink**
14 × 18 cm (5¾ × 7 in)
The emphasis here is on the pink dress; even though the figures in the foreground are larger they still support the figure in pink as a focal point.

Paints

Watercolour paints come in a variety of ranges and brands. All watercolours should be compatible no matter what the manufacturer's name, so you can pick and choose whichever colours suit you. Artist's quality paints have the greatest pigment content and luminosity – the cheaper equivalents in student ranges contain extenders and bulking agents which can create problems, so on the whole you get what you pay for.

Watercolours are sold either in pans or tubes. You can buy the former separately or in boxed sets in various ranges. I have used tube colours for all of the paintings in this book as I find they give me access to larger flowing washes instantly. They are ideal for studio use, but if you wish to take minimal equipment on location a neat little paintbox with pan colours and a palette in the lid is undeniably handy.

Brushes

You won't need a lot of brushes to start with – just three round or mop brushes in varying sizes would be ideal. Equip yourself with a No. 16 for large areas of colour and background washes, a No. 10 for intermediate washes and smaller paintings and a No. 8 round brush that comes to a fine tip for most of the smaller and more detailed areas. The latter will do a lot of laborious work and you will probably find it familiar to handle. Given extra use, it's likely it will wear out more quickly than the others – if you notice it's losing its tip, replace it.

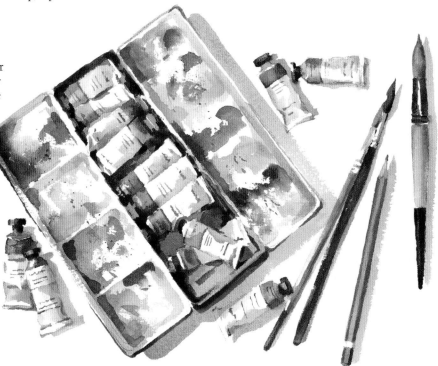

▼ **Painting kit**
A tin box will hold tube paints and double as a palette; most have extension mixing spaces. Three brushes are enough, with a 2B pencil for sketching.

Paper

Ideally, you should use nothing but the very best watercolour papers. For top-quality results choose mould-made papers that have a high cotton rag content, usually sold in single sheets or blocks. The manufacturers will usually guarantee their performance and replace any faulty sheets.

Watercolour paper comes in a choice of three surfaces: hot-pressed (HP), which is smooth, Rough, with a textured surface, and cold-pressed (Not), which is in between. Take great care of your paper – the surface is a delicate one.

For painting small 30-minute pictures I recommend a 300 gsm (140 lb) or 640 gsm (300 lb) Not paper made by Arches or Saunders Waterford. You will also need some cartridge paper for drawing on – pads are readily available in most art shops at very reasonable prices.

◀ **Extras**
Outlay on other equipment is minimal – you probably already own a craft knife and a hairdryer. A putty eraser and a roll of masking tape are all the extras you need to buy to get started.

Other items

A good flat surface to work on is essential – a sturdy table or desk and a drawing board to which to attach your paper. An empty jamjar or coffee jar will make an ideal water container. A roll of masking tape (sometimes called picture tape) will enable you to fasten your paper to your board and even stop any photographic reference you are using from blowing around when you turn on a hairdryer to speed up your drying times.

A putty eraser is the only type of eraser that is safe for getting rid of unwanted pencil marks or blemishes as it will not damage the paper surface if used delicately. Lastly, you will need a craft knife for cutting paper and scratching out on a painting.

▌QUICK TIP

Elastic bands are very useful for holding down the pages of a watercolour sketchbook when you are working on location, especially on a windy day.

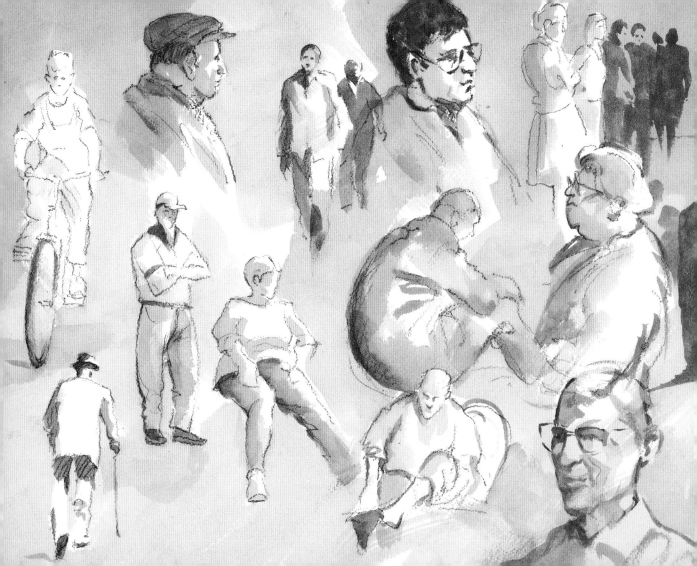

SKETCHING PEOPLE

Many of us occasionally engage in the habit of 'people-watching', as it is called, but for an artist this is a necessity. Studying the actions and movements of others is a very rewarding pastime, since observation is the key to drawing and capturing a certain gesture or pose can bring your painting to life. There is no need to worry about getting everything exactly right – sketching is for exploration and practice, not for display.

Even doodling while you are watching the television is a useful discipline as it will teach you to sketch rapidly and react to what is in front of you. All sketching is good sketching and your skills will develop in accordance with the amount of practice you put in.

◀ **Sketch sheet**
This is a preparatory sketch page. Simple pencil outlines were used first to support loose washes of Burnt Sienna and Coeruleum.

Quick sketches

The whole process of translating a pencil line to paint should inspire you to complete a sketch in double-quick time. It is ideal for capturing a loose resemblance, but many of my students overdo the painting part of this exercise by trying to cram in too much information – so remember to keep things simple.

Starting with pencil

Begin your quick sketches with a sharpened 2B pencil on cartridge paper. Try to use a continuous line – in other words, keep the pencil on the paper as much as possible. Your sketches should be only about 5–7 cm (2–3 in) high, as this will eliminate the temptation to put in too much detail. Give yourself a time limit for each sketch, say about 3–5

minutes each. When you get a rhythm going your figures will start to have more movement.

Within 30 minutes you should have between seven and ten little vignettes of people and some idea about where colours should be placed, as this type of drawing gives you basic information to guide you towards what you will do in paint later on.

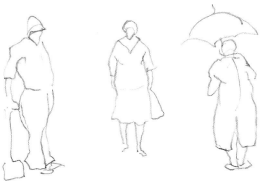

▶ **Pencil figures**
These figures have been drawn using a continuous line with a 2B pencil on cartridge paper.

Progressing to paint

Next use a No. 8 brush, keeping your block colours simple, in single strokes with continuous movement. Don't try to work over previously painted areas since the cartridge paper won't allow this, and don't add in eyes, noses and other small details as this will overcomplicate things. Instead, try leaving some whites from the paper. You should end up with simple, fresh statements that will encourage you to take the next step.

QUICK TIP

Work with a limited palette of four or five colours at first, practising colour mixing as well as application.

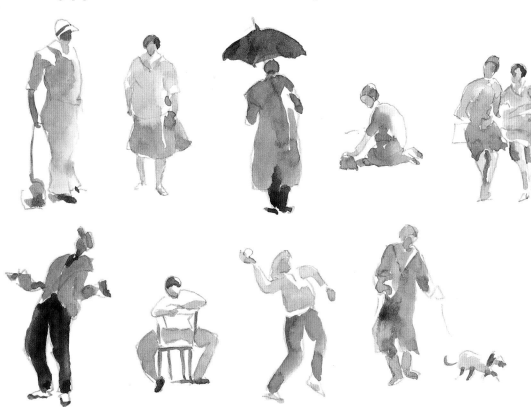

◀ **Adding paint**
Simple colours blocked in on the major shapes without overworking them give a fresh look to sketches.

Human proportions

Knowing the proportions of the human figure gives you a reference guide when you are drawing or painting people – though this is not an exact science, as proportions depend on the pose that the subject is seen in and, of course, their personal characteristics.

As a rough guide to getting proportions correct, using a measurement of heads is a convenient method. For example, an adult standing figure is approximately seven and a half heads high, but this varies if they are wearing a hat or high heels. A seated figure is about five and a half heads high from head to foot, depending on the type of pose the sitter is in.

Children's heads are larger in proportion to their bodies. When they are very young their heads represent about a quarter of their height, while by six or seven the balance has changed to about a sixth. The viewer's eye will interpret the age of a child not just by their height but also by their proportions, so use your observation to establish what is correct if you wish to depict a particular child or age.

If you use these general guidelines to measurements, with practice you will get your figures looking right. The most common error is in making the head of your figure too large, so be especially wary of this.

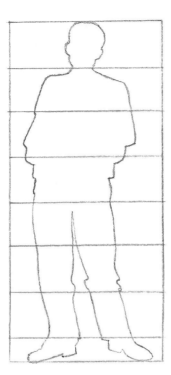

▲ **The adult figure**
The proportions shown here of 7½ heads represent the average adult figure, seen at eye level.

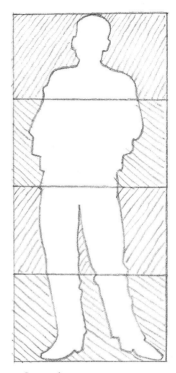

▲ **Quartering**
If the overall figure needs adjusting, dividing it into four equal sections makes each easier to alter in relation to the others.

Making boxes

A useful aid to getting proportions correct is to create imaginary boxes into which to fit your figure, which will help you to map out the general angles of the pose before the details are put in. This will also help you to get a more three-dimensional result. You will want your figure looking as natural as possible, so pay particular attention to the drop of the shoulders, the direction of the feet and hands and the tilt of the head.

▶ **Boxed proportions**
Making guidelines of box shapes is particularly helpful for poses where the figure is foreshortened.

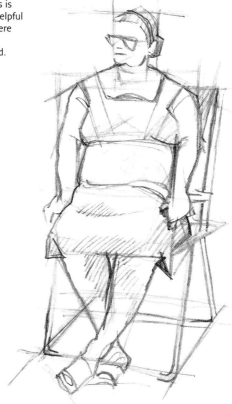

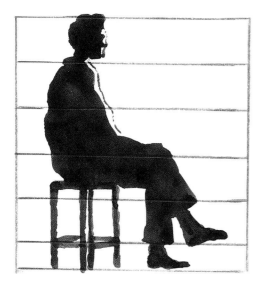

◀ In the case of a seated figure, the proportions are 5½ heads.

Using watercolour

Watercolour can be a tricky medium to operate and many students complain about feeling out of control when the paint hits the water. However, it's true to say that water and colour work best together when there is a flow and colours are allowed to merge together naturally.

When I was an art student I asked my tutor, 'What is the skill of watercolour?' He replied, 'Take the colours and water and swirl them on to the paper in the shapes you want, then let them dry and swirl some more colours on top to trap the light. That's it!' His answer astounded me, but I've been practising this ever since and it still astounds me today. Watercolour responds to brevity – a few well-placed marks can say a thousand things.

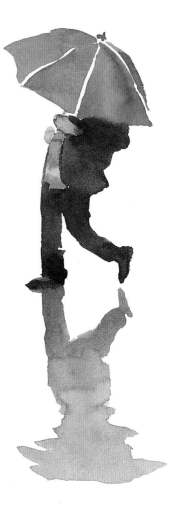

▶ **The Blue Brolly**
It's always fun to leave something for the viewer's imagination to do. This figure is not so much about what's been painted but what's been left out.

◀ **Seated Couple**
All the work here is done by the white of the paper being left unpainted, representing the light that hits the figures.

Wet-into-wet

This technique is used to create a soft edge or diffusion of colours by applying one layer of colour over another while it is still wet. You can alter the amount of diffusion by controlling the flow of liquid and the colour from the brush, but don't hope to be able to control everything – the joy of watercolour is that it will do what it wants and you will find unexpected and beautiful effects occurring in front of your eyes.

You can achieve different effects by varying the amounts of liquid and the timing, for instance dropping undiluted paint into a damp wash or applying a half-and-half mix of paint and water in the brush to a very wet surface. For maximum control, always use less liquid in the brush than is on the paper.

Try to use single brushstrokes rather than blending with the brush. Resisting the temptation to blend will produce a fresher and more spontaneous look.

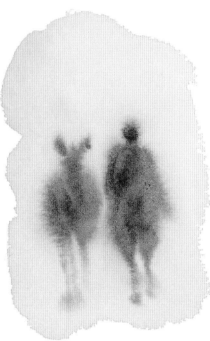

◀ With a No.10 brush, create a wash of Indian Yellow then dry the brush until it is merely damp. Pick up some Burnt Umber with the tip of the brush and draw your image into the wet wash.

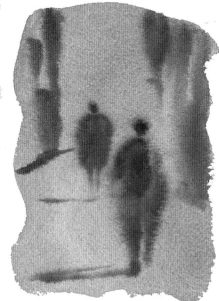

▶ Again using the No.10 brush, lay down a wash of Cobalt Blue. This time mix together two colours, say Cobalt Blue and Permanent Rose, and brush them in at different strengths.

QUICK TIP

Darker colours dropped into pale washes give the best results. Be prepared to wait a few moments after applying the first wash before dropping more paint in.

Painting around shapes

You will often be required to paint around shapes so it is worth spending some time practising this, using the white surface of the paper for ease. Keep your shape combinations simple – squares, circles and triangles, for example, which can be effectively employed later on.

Use a No. 16 brush and apply your washes as flat as possible. Don't spend too much time around the edges of the white shapes, since broken edges can be used as effectively as sharp ones.

Trapping hard shapes from washes in this way is a mainstay in watercolour technique and can produce stunning effects of clarity when done with a skilled hand. Try to visualize your shape on the paper before painting, then work quickly and don't panic!

◀ Here a mixture of Cobalt Blue and Permanent Rose has been painted around figure-like shapes to be developed later.

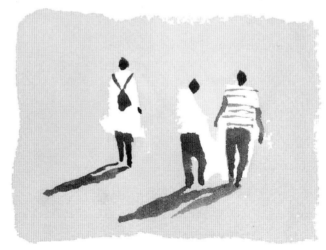

◀ A wash of Raw Sienna captured the white shapes then, after this was dry, the figures were developed with a strong mix of Burnt Umber.

QUICK TIP

Have enough paint mixed up in your palette for the first wash. It's never a good idea to run out halfway through!

Glazing

The technique of glazing employs the transparent nature of watercolour paints. Some colours are more transparent than others, and tubes will usually have this specified on their labels underneath the name of the colour – for example, 'Burnt Umber, Series A, Transparent'. If you are in any doubt, you can check on the manufacturer's leaflet that always accompanies good-quality paints.

Before trying to glaze a painting you feel you will want to keep, practise the technique first on small paintings done for this purpose. Let your painting dry before attempting to glaze another colour over it and then use single strokes of the brush loaded with plenty of wash and colour. You must take care not to lift the colours underneath, so avoid scrubbing or fiddling.

▷ Red, yellow and blue used as glazes on top of one another create an extra three colours in the viewer's eye.

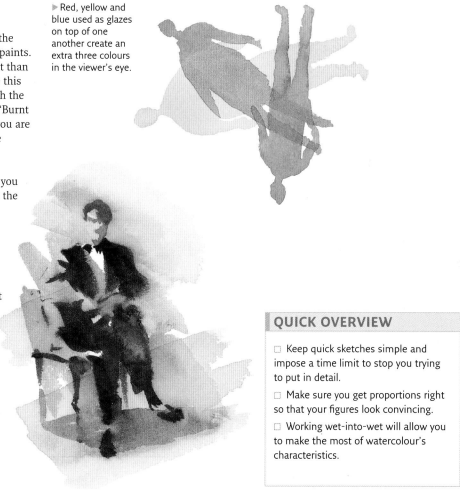

▷ Here a small painting was done leaving large areas to be glazed later with washes of French Ultramarine, Permanent Rose and Indian Yellow.

QUICK OVERVIEW

☐ Keep quick sketches simple and impose a time limit to stop you trying to put in detail.

☐ Make sure you get proportions right so that your figures look convincing.

☐ Working wet-into-wet will allow you to make the most of watercolour's characteristics.

Merging colours

Watercolour pigments will merge together naturally when wet and you can use this to your advantage. For this project, try to get a flow of colours going while you are painting people, thinking about the overall shape of the painting and not the details.

Going with the flow

Start with a light pencil line on a piece of 300 gsm (140 lb) Not watercolour paper, mapping out the whole composition before painting.

Have all your colours to hand before making up your first wash. Paint in the heads of your people first and then mix and merge the colours, letting them flow over the pencil lines and into one another. Drop various colours of your choice into the wet washes, mixing different consistencies in order to give varying diffusions and stronger colours to create dark values.

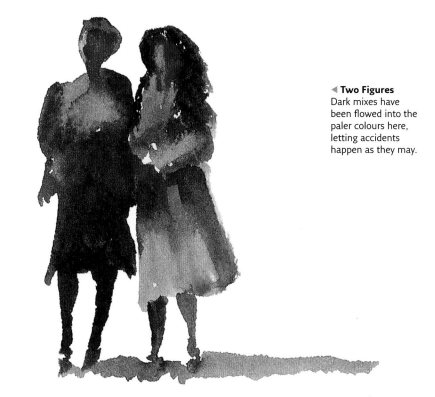

◄ **Two Figures**
Dark mixes have been flowed into the paler colours here, letting accidents happen as they may.

It doesn't matter if one figure merges with another at this stage – you can separate them at a later date when your wash dries. Your initial aim is to let the colours merge over the whole composition so that exciting diffusions occur as they begin to blend on the paper. It is difficult to prevent these accidents, so don't try – instead, take advantage of whatever happens when the paint begins to flow. It is the accidental nature of this medium that makes it so enthralling to use.

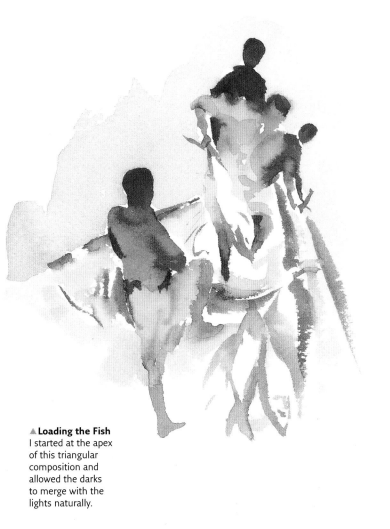

▲Loading the Fish
I started at the apex of this triangular composition and allowed the darks to merge with the lights naturally.

▼ In the Souk
25.5 × 20 cm (10 × 8 in)
In this painting the dark tones were put down last and allowed to merge, providing a rhythm for the whole design.

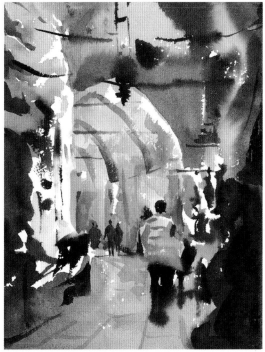

FROM SKETCHING TO PAINTING

Once you have begun to sketch people on a regular basis you will become more comfortable with a pencil and more confident about your ability to paint as well. As you progress, you should begin to make a conscious attempt to drop the outlines in favour of painted shapes so that you can achieve a more intuitive look to your watercolours.

Direct painting with the brush and colours onto the paper is a very exciting way of working with this medium and will lead to a more expressive feeling in the picture as shapes, colours and tonality become ascendant over outlines and details. You will make mistakes, of course, but that's all part of the journey.

◄ **Moroccan Market**
23 × 33 cm (9 × 13 in)
In this painting, shapes and tones override outlines and details in order to capture the moment. I chose to paint the light instead of the subjects.

Simple silhouettes

Silhouette painting is fundamental to watercolour sketching and an ideal way of learning how to free yourself from the constrictions of outline-based work. Simple silhouette figures in one colour are the first things to practise; they will enable you to put people in your existing paintings as well as develop new ones based on this skill.

At this stage, small is good. The paintings on these pages are no more than 4 cm (1¾ in) in height, which is a manageable size for small watercolours. Use one colour at a time for this – Burnt Umber is good to start with as it's very transparent and can be mixed up to a rich dark. When you feel confident with this, move on to another colour and so on.

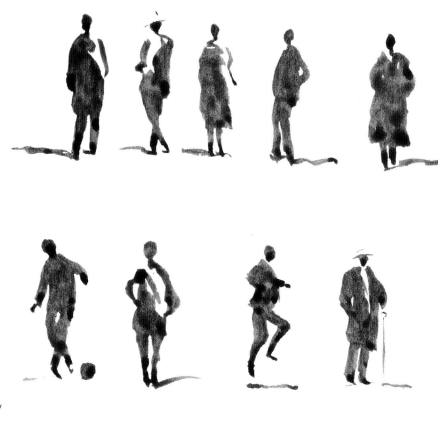

▷ **Silhouette figures**
These silhouettes were painted with a No. 8 brush straight onto cartridge paper as a study sheet. They are no more than 4 cm (1¾ in) high.

Adding expression

Once you have formed several figures, using only the brush and simple poses, progress to more expressive movement. Painted people caught in the action of doing something are always telling a story of some kind and it is good practice to allow your brush to wander, leaving some occasional white shapes for the viewer's imagination to feed on.

When you are creating these small silhouettes try to paint instinctively, following the flow of the figure and its movement. Keep checking that your general proportions are correct and make sure your brush is well loaded with paint.

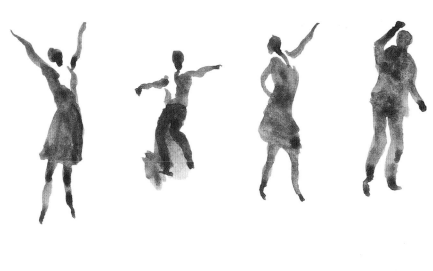

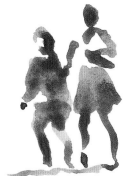

▶ **Expressive figures**
Here Burnt Umber and Coeruleum are used together. These two colours separate slightly to give an uneven mix, adding to the vitality of the figures.

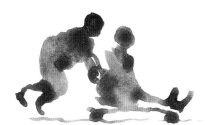

Using the brush

The brush is one of the most valuable tools an artist possesses and good ones are much prized by watercolourists. It is important that your brush has a good body of hair and will come to a fine, needle-like tip when wet. The fine point of the brush can be used to delineate even the smallest of shapes when painting a figure.

Pushing to form shapes

Load your No. 8 brush fully and place it on the paper, where a blob of colour will form. Push the blob outwards to form the shape you require rather than drawing with it and then filling in.

You may not be able to complete a whole silhouette with just one brushload, so get into the habit of returning to the palette to recharge the brush with more colour. Add this to the existing wet colour on the paper and let them flood together, then move on to complete your figure.

◀ **Profile**
The initial blob of colour has been pushed outwards from the centre to form the shape of a female profile.

◀ **Standing Figure**
Here the same technique has been used, but the white paper pierces the silhouette through the left arm and legs.

◀ **Couple**
These two figures painted with Cadmium Orange are linked so that they join together as one silhouette.

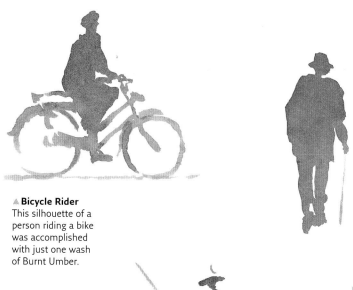

Walking Stick
Using one colour can
be very descriptive,
but combining
several colours to
form a single
silhouette gives more
expressive results.

Bicycle Rider
This silhouette of a
person riding a bike
was accomplished
with just one wash
of Burnt Umber.

African Girl
Subdivisions can be
painted after the
silhouette wash is
dry. The darker wash
to form the features
and patterns was
put in last.

Boatman
Here more white
paper has been left
to interact with the
silhouette and create
the illusion of form.

Shape and tone

To make a successful painting in 30 minutes you will need to study the sequence of tones and shapes you will use. It is important to look at the way they interlock in order to produce an interesting and dynamic image.

Getting the tonal balance right creates a harmonizing effect in a composition. Simplification is the key to this, and by reducing the number of tones used in a picture you will both create more impact and gain confidence that you can paint it.

When you are looking for tonal sequences in a subject, try squinting at it through half-closed eyes. This has the effect of minimizing colour and thus making major shapes and tones more apparent, so you will be able to see the arrangement of these in a simplified form. Knowing what to paint in and what to leave out is half the battle here, and this will help you in your decisions.

▶ **Men at Work**
This study was done with mixes of Lamp Black and Cobalt Blue and just five tones. Tone 1 is the white paper; tone 2 is the background sky; tone 3 is a darker tone to represent the shirts and shadows; tone 4 is found in the arms, heads and foreground; and tone 5 is for darker emphasis on some clothing.

Tone 1

Tone 2

Tone 3

Tone 4

Tone 5

QUICK TIP

Try to restrict your range of tones to just four or five. If you use more it will make the task much harder.

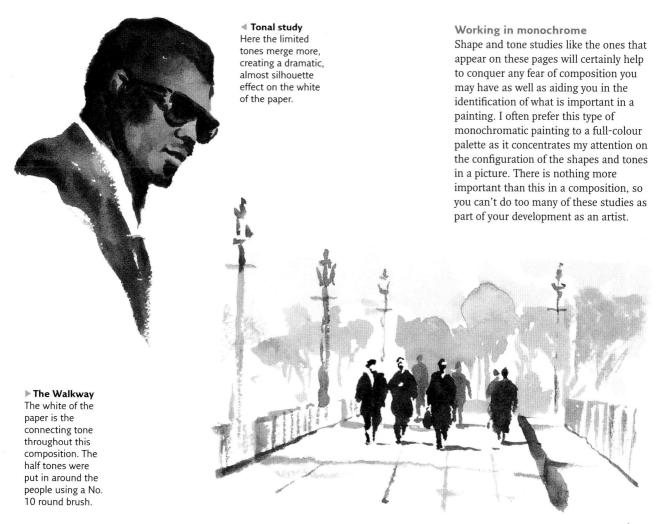

◀ Tonal study
Here the limited tones merge more, creating a dramatic, almost silhouette effect on the white of the paper.

Working in monochrome

Shape and tone studies like the ones that appear on these pages will certainly help to conquer any fear of composition you may have as well as aiding you in the identification of what is important in a painting. I often prefer this type of monochromatic painting to a full-colour palette as it concentrates my attention on the configuration of the shapes and tones in a picture. There is nothing more important than this in a composition, so you can't do too many of these studies as part of your development as an artist.

▶ The Walkway
The white of the paper is the connecting tone throughout this composition. The half tones were put in around the people using a No. 10 round brush.

Using tone with colour

In order to create a picture that has a three-dimensional structure you need to be able to represent the objects you are painting with their correct tonal values, otherwise it will look flat and unconvincing. When you have achieved a correct tonal balance you can rely on this tonal structure to help you get the colours right.

First make a monochromatic painting, limiting your choice of tones to three or four. Use the white of the paper for the lightest areas and Lamp Black for the darkest ones. Two tones of grey should be enough to simplify all the half-tone areas in between the white and the black.

Make up your tonal range in separate wells on your mixing palette and try not to cross-mix or blend them when you paint. Draw out your subject on the paper with a 2B pencil to indicate where the tones will go then fill them in, making your applications as flat as possible.

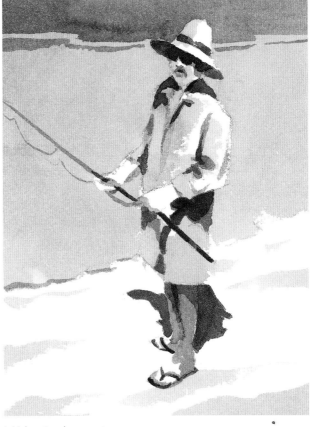

▶ Make a tonal range of four values from white to black so you can match your colours to them.

◀ **The Fisherman 1**
Four tones were enough to complete this tonal study, which gave me a better understanding of how light or dark to make my colours.

▶ The Fisherman 2
I added small parts of Lamp Black to some of the colours here to achieve the correct tones.

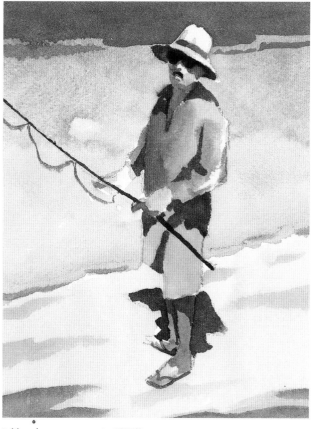

▶ My colours were kept to a simple range of just four, including Lamp Black for darker tones.

Adding colour

Now it's time to work with colours; after completing your study in tone you should have a better idea of what they are to be and where they should be placed. Keep your choice of colours limited to about four or five, making one of them Lamp Black to help you in achieving the correct tone, since some colours are not dark enough on their own and may need small quantities of black added to them.

Mix your colours together to match the local colours in your subject and then check them against your white to black range to see if they are correct in tonal value. At this stage it is acceptable to cross-mix colours to achieve a result. Paint in your colours only when you are sure that their tonal value is correct.

QUICK OVERVIEW

☐ Practise painting silhouettes to loosen up your technique and move away from outline drawing.

☐ Look for the sequences of shape and tone in your subject.

☐ Remember that all colour has tone and limit your colours to make it easier for you to create a good tonal balance in your pictures.

Looking at shapes

Gaining an understanding of the underlying shapes in a subject and how they fit together makes it much easier and quicker to achieve a painting rather than getting caught up in the details. This approach will also lead to a bolder and more confident result. For this project, try some shape-building to see what it can do.

▲ **Man in a Boat 1**
Here I have drawn in the basic dark shapes with a simplified outline, judging their size and relative distance from one another.

▼ **Man in a Boat 2**
In this little painting the dark shapes are the ones that dominate and link all the subject matter together. These darks alone give the picture its impact.

Starting to draw

Look at the overall shape you are about to paint and decide on its size and location on the paper. Draw it in, leaving out all of the internal and external details. Shape identification can be made easier by thinking in terms of squares, circles and triangles, and looking at your subject through half-closed eyes might be useful in drowning out the details to give a clearer view of the basic shapes.

If you are working from a photograph, try turning it upside down as this very often makes the hidden abstract shapes easier to identify. Once you start to see merely shapes rather than recognizing familiar objects it will make the task simpler to achieve.

Darker shapes

Sometimes the darker shapes are the key to simplicity and are easier to spot. Look at how they are placed in your composition and what relative sizes they are. Do they connect, or are they like stepping stones running through your picture? Making this kind of judgement about shapes will invariably lead to stronger designs.

▼ At the Easel 1
This drawing shows how some shapes are connected to others and how the background will often invade the subject.

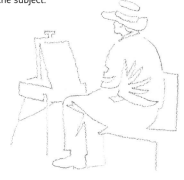

▶ At the Easel 2
My initial drawing gave me a clearer view of what to do with the paint and made the process of painting this much easier.

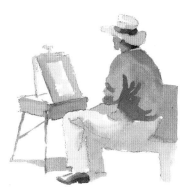

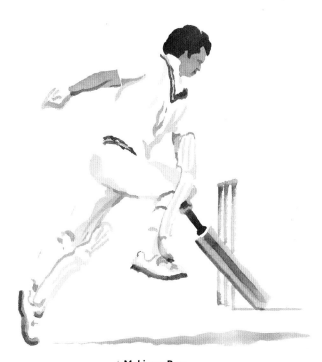

▲ Making a Run
This turned out to be a strong design because of the placement of the shapes. The white of the paper is allowed to move throughout the whole picture.

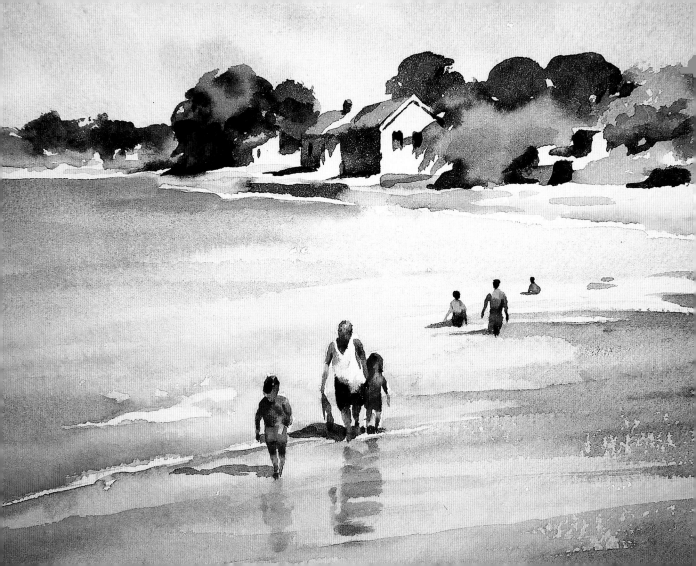

EXPLORING COLOUR

Colour not only provides an extra way of creating form and perspective in a picture, it also dictates the mood or feeling that the viewer will respond to. In addition, it is highly satisfying and exciting for an artist to work with.

Although colour selection is a personal choice, it is true to say that cool colours will invariably make objects recede in a painting while warmer colours will bring them forward. Nevertheless, there are cooler and warmer versions of all colours, so with clever handling you can play with recession and perspective as you wish. This chapter will help you to embark on a colour journey with your brushes and paints and find out how they work along the way.

◀ **Bajan Paddlers**
23 × 33 cm (9 × 13 in)
Painted in Barbados, this small painting shows how colours can be used to create recession and a feeling of space.

The colour palette

The palette I have chosen to work with in this book contains 14 colours with as many primaries (blues, yellows and reds) as possible. These are essential, because so many secondary mixes can be made from a wide source of primaries. A vast array of greens and purples will result from these secondary mixes, which makes the choice of colour for each painting an exciting one.

The palette also contains two browns, Burnt Umber and Burnt Sienna, which are relevant to flesh tones and bring warmth to shadows, and Lamp Black and Chinese White.

Using black and white

Lamp Black and Chinese White are rarely used these days but have a multitude of different benefits in painting people in watercolour. The black can neutralize colours, add depth of tone to your paintings and create dramatic effects in your compositions. It is very warm and transparent and can be mixed freely with any pigment with the tint of the colour still showing through. For example, if mixed with yellows it will combine to give you rich, dark greens – but beware of overworking it as the results could be very muddy.

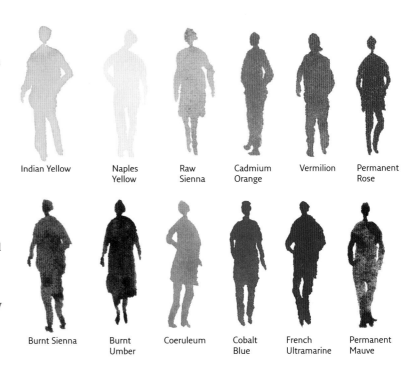

Indian Yellow Naples Yellow Raw Sienna Cadmium Orange Vermilion Permanent Rose

Burnt Sienna Burnt Umber Coeruleum Cobalt Blue French Ultramarine Permanent Mauve

Chinese White will sit on top of other colours when they are dry and allow them to show through. It can also be used to bring body and density to thin colours so that they have more covering power where needed. However, it is not a remedy for covering up mistakes!

Lamp Black Chinese White

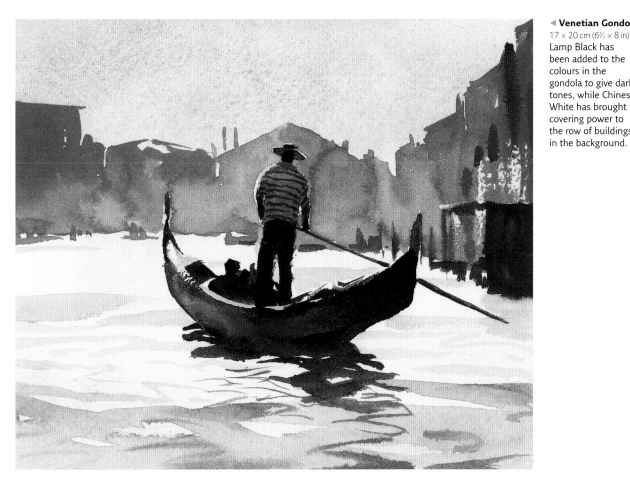

◀ **Venetian Gondola**
17 × 20 cm (6½ × 8 in)
Lamp Black has been added to the colours in the gondola to give dark tones, while Chinese White has brought covering power to the row of buildings in the background.

Painting with primaries

On these two pages you will find examples of painting with a limited primary palette of just three colours – red, yellow and blue. This type of exercise will focus your mind on mixing and gauging strength of tone, so it's a great learning curve as well as producing some startling little paintings. It's surprising what can come from this reduced selection of colours; I often start a painting by simply letting my colours mix freely on the paper, using diluted primaries.

Practise mixing first to see what colours can be made in the palette, then apply some swatches to a scrap piece of watercolour paper. Two-colour combinations will result in secondary colours of orange, green and purple. Vary the quantities when you want to try three-colour combinations as this will place an emphasis on one colour in the mix and avoid a muddy effect, which is always a danger when you mix more than two colours together. Glazing one colour over another when dry will also give you a third colour, as a result of mixing in the eye (see page 23).

When you have exhausted one set of primary colours, move onto further sets of different reds, yellows and blues and repeat the practice. A gallery of small paintings, each one accomplished in 30 minutes, should start to appear after several sessions.

▶ **Cornish Boat**
9 × 13 cm (3½ × 5¼)
I kept largely to my basic primary selection here, with not many secondary mixes. A large wash of French Ultramarine was applied after the boat and figures were painted.

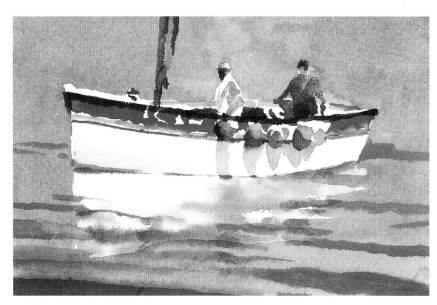

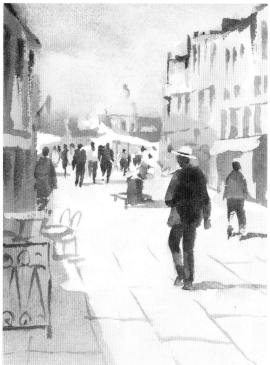

◀ Venetian Street

15.5cm × 12 cm
(6¼ × 4¾ in)
In this painting I let my primary selection mix on the paper first, putting my people and buildings on after this was dry.

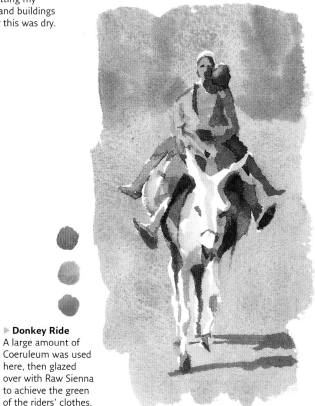

▶ Donkey Ride

A large amount of Coeruleum was used here, then glazed over with Raw Sienna to achieve the green of the riders' clothes.

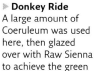

▍QUICK TIP

When you've selected your palette, first try a concentrated mix of the blue and the red. This will be the darkest available tone.

Local colour

The term 'local colour' refers to the basic colour of an object irrespective of surrounding influences such as shadows and reflections. For example, the local colour of a dress could be described as French Ultramarine.

Identifying local colour should be easy and obvious, but it is a bit more difficult to see the influences other colours can have on it. Sometimes you will want to paint a person's clothing in various shades of the local colour, in which case you can simply alter the strength of the colour. However, if the local colour is bright yellow or white, the shadow areas and folds could be somewhat tricky to achieve without adding another colour. This is where the colour mixes can come in handy.

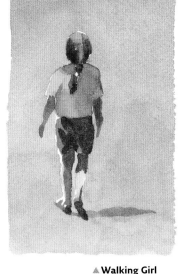

▲ **Walking Girl**
Here French Ultramarine was added to the Indian Yellow on the T-shirt to create the green shadows.

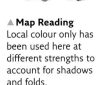

▲ **Map Reading**
Local colour only has been used here at different strengths to account for shadows and folds.

▶ **Seated Figure**
Other colours have been added to the local colours in this study, especially in the shadows and folds.

Neutralizing colour

There are so many options when it comes to neutralizing colour that the list could be very long and very confusing. However, there are some standard ways that are tried and trusted, so your best plan is to use these before moving on to be more experimental.

Certain colours can look too powerful or garish in a composition and you will want to subdue this effect by taking away the colour saturation but still keeping the exact tone. You can do this by mixing earth colours such as Burnt Umber, Naples Yellow and Raw Sienna with the more vibrant colours to neutralize them.

For example, when you are mixing up a wash of French Ultramarine in the palette, adding a little Burnt Umber will immediately subdue the colour. If the wash darkens, add some clear water to bring it back to the correct tone. Naples Yellow will neutralize the lighter colours in the same way but without the need to adjust the tone.

▼ **Waiting**
In this little study I neutralized all the other colours by mixing Naples Yellow in the light areas and Burnt Umber in the darks.

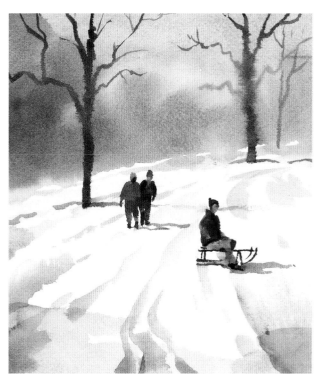

▲ **Snow Play**
18 × 16 cm (7 × 6¼ in)
Burnt Umber was used in this painting to subdue all the other colours and give a subtle suggestion of snow.

QUICK TIP

When neutralizing colour, try using uneven amounts in the mix – for example more blue than brown or vice versa.

Reflective colour

Colours will sometimes reflect on other surfaces or bounce from one place to another, depending on the lighting conditions. This is an elusive quality but worth capturing, especially when you are painting people in close-up.

This effect can be seen very clearly with stage lighting in theatres and clubs – coloured filters are used on lights in these places and unusual colours are reflected on the performers' costumes and skin. These conditions are very rewarding for a watercolourist because they offer the opportunity to use fully saturated colours and dramatic tonal contrasts. The complementary colours red and green, orange and blue and purple and yellow can often be seen clearly opposing one another.

Reflected colour can be seen in nature too, as shown by the old trick of placing a buttercup under someone's chin to supposedly discover if they like butter.

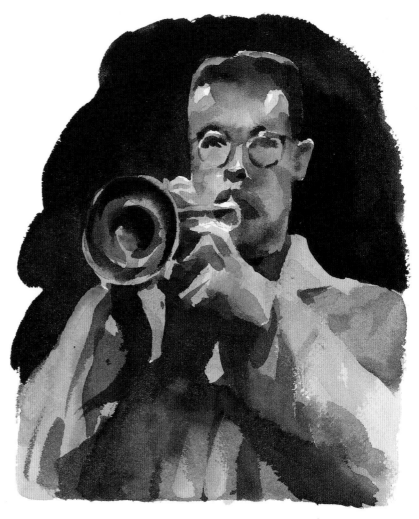

▶ **Trumpet Player**
I used Lamp Black to trap all the reflected colour on this trumpeter, seen under stage lighting.

Old Friends

The evening light reflected oranges and yellows on the two old men.

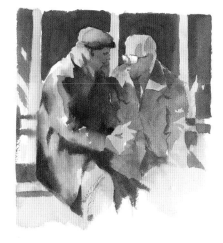

Sax Man

21 × 18 cm (8½ × 7 in)
Complementary colours of orange and blue are reflecting on everything here, including the jacket and face.

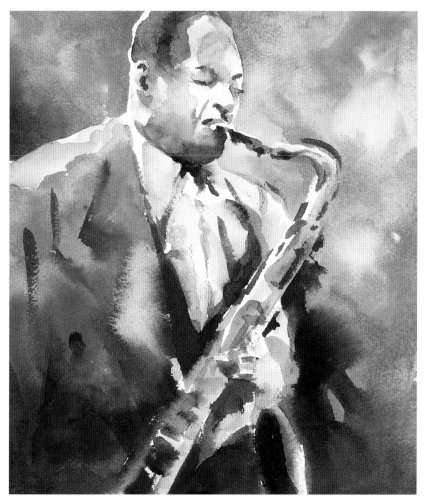

Flesh colours

When you see a colour described as 'flesh pink' it is usually a slightly murky pink/beige shade. In fact, the reflective nature of skin means that it can be almost any colour.

However, you will want to discover how to estimate the subtle changes of skin tones, along with what colours to use and where. This is where the practice of observation plays a key role. Pinks, oranges and reds are important, but don't discount blues and greens, browns and purples. The more colours you can see the more you can use.

◀ Pale washes of Vermilion, Coeruleum, Cadmium Orange and Indian Yellow.

▶ These washes were flooded onto the paper in the general areas of exposed flesh, going for the overall shape of the subject.

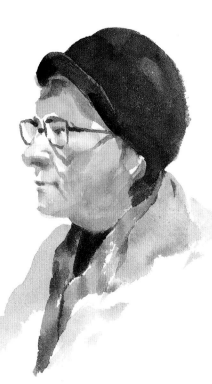

▶ **Lady with a Hat**
Features and clothing were put in next, with details such as the scarf and spectacles laid in last of all.

Reflections on skin

You have already discovered from pages 46–7 that reflected colour comes into play, so start by observing the colours surrounding the person you are going to paint to see if these have an influence on their skin. The quality of light that hits your subject will also have a bearing on the colours you choose for flesh tones.

Select three or four main colours that are suitable to represent those you can see on your subject's skin and make up pale washes. Flood these colours into the flesh areas on the subject, leaving untouched paper for highlights. Finally, work in any other features, such as shadows or clothing, when the first washes are dry.

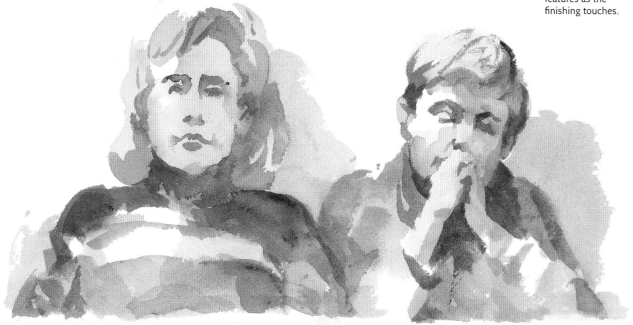

▼ **Two Seated People**
Little studies like this one can often turn into finished paintings. Here I washed in my pale flesh colours first and then expanded on this with further colours to determine the clothes and shadows, adding the features as the finishing touches.

Colour mixing

There are three different methods of colour mixing with watercolour, and working with all of them will give plenty of interest to your paintings.

Mixing in the palette is the standard form of controlling the outcome of the mix, but this will slightly dull the colours on application. Mixing on the paper, where you add colours individually to your surface and allow them to merge together there, will give the brightest effects. The third method is mixing in the eye, where glazing over dry colours produces a third colour in the eye of the viewer (see page 23).

You will need plenty of practice to gain mastery of these mixing procedures. When you first begin, try to keep an open mind and use odd combinations; you will find that two-colour mixing is easier to handle and gives clearer results. Experimentation is of the essence, so have fun and play with the paint.

When you are working on a particular painting and wish to test your mixes, a practical way of doing this is to try them on scrap paper while you are waiting for washes to dry.

▶ Colours that are allowed to merge on the paper do so unevenly and produce a unique mix every time.

Raw Sienna + Coeruleum

Vermilion + Cobalt Blue

Lamp Black + Burnt Sienna

Burnt Sienna + Cobalt Blue

Naples Yellow + Cadmium Orange

Indian Yellow + Lamp Black

Darker colours

Mixing darker colours in watercolour without producing a muddy effect is notoriously difficult. Keeping them rich, colourful and transparent depends as much on the mix as it does on the application. The answer is to stick to two-colour mixes, make your application as direct as possible and avoid overworking. Don't spread the paint too far – instead, keep loading your brush and adding to the mix on the paper.

Shown here are five two-colour mixes which you will find very useful.

▼ All these darks were achieved in the palette by mixing two colours together. I kept plenty of the mix on the paper and in the brush on application.

Cobalt Blue +
Cadmium Orange

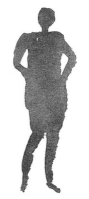

Cobalt Blue +
Vermilion

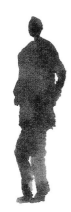

Coeruleum +
Burnt Umber

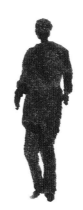

Permanent Mauve
+ Vermilion

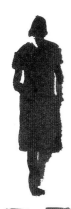

French Ultramarine
+ Permanent Rose

Using six colours

Using just six colours in a small 30-minute painting eliminates the confusing choices that a full palette will incur. Leaving white paper showing will give additional highlights that will bring an extra sparkle to the colours.

2B pencil
No. 8 and No. 10
 round brushes
Arches 300 gsm
 (140 lb) Not paper
Cadmium Orange
Cobalt Blue
Coeruleum
Permanent Rose
Raw Sienna
Vermilion

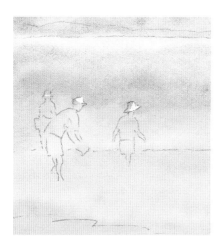

1 Lightly draw in your subject with your 2B pencil, indicating where major changes will happen in tone and colour. Using all the colours and the No. 10 brush, begin to lay down a wash of pale tones over the whole paper, being careful to paint around the lightest areas and trap the white paper for the highlights. Move from left to right and top to bottom until the whole surface is covered, gradually bringing the warmer colours into the foreground.

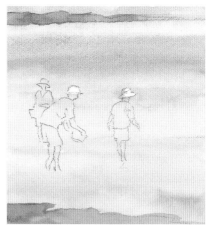

2 When your first wash is thoroughly dry, mix up a green from Raw Sienna and Coeruleum and a purple from Cobalt Blue and Permanent Rose. Put them in the background headland, letting them merge in patches. In the foreground, use mixes of Cadmium Orange and Raw Sienna and let these merge into the beach area. While they are still wet, drop in some of your mixed purple in one or two areas. Let this dry.

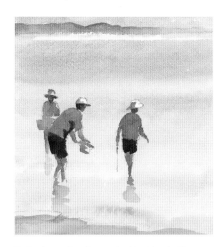

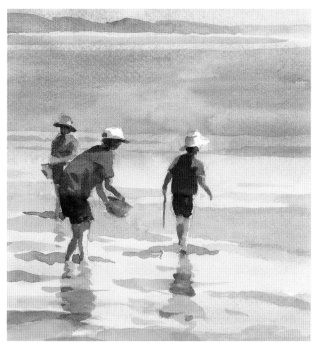

The Waders
17 × 16.5 cm
(6¾ × 6½ in)

3 Begin on the figures by blocking in the basic colours of their clothing. Start on the left-hand side and use Coeruleum for the hat, trapping a light area on it from the backwash. For the head, mix Vermilion with a small amount of Coeruleum. The shirt is a concentration of Raw Sienna. Wash in the middle figure's T-shirt with Vermilion then darken the shadow with Cobalt Blue. For the third figure, use a strong wash of Cadmium Orange and, for the shorts, stronger mixes of Cobalt Blue and Vermilion and a little Cadmium Orange. Wash in mixes of Permanent Rose and Raw Sienna for the legs and reflections.

4 Mix up a brown with Raw Sienna, Cobalt Blue and a touch of Vermilion. Place this on the shadow side of the figure on the left, on the head of the central figure and, adding more Vermilion, on the shadowed T-shirt of the last figure. Develop the reflections using stronger washes of their original colours and Vermilion. Add further washes of Cobalt Blue to the sea then use a mix of Coeruleum and Permanent Rose for the foreground shadows.

◀ The Waders
17 × 16.5 cm
(6¾ × 6½ in)

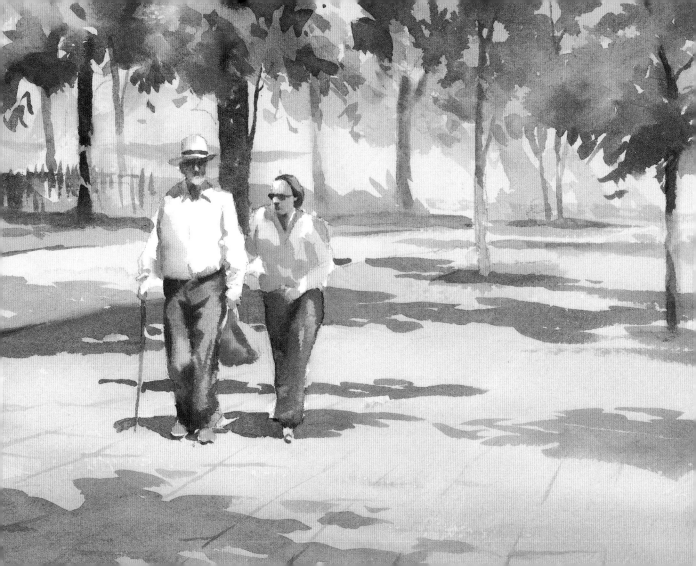

SHADOW PLAY

In order to show light in a watercolour it's imperative to make yourself a painter of shadows, since capturing a moment in time is intrinsically bound up with identifying the interaction between light and shade. This gives a painting a magical quality and can make the difference between a pedestrian picture and a stunning one.

Often, shadows are themselves the subject; they alone represent the story in a picture. Their importance means that the constant study of shadows and their shapes, configurations and colours is both complex and rewarding. In this chapter, you will discover some of the aspects of using shadows and how to translate them into paint in only 30 minutes.

◀ **A Walk in the Park**
25.5 × 34 cm
(10 × 13½ in)
In this painting the cast shadows from the trees play as important a role as the people. Shadows fall across all the elements in this picture.

Shadow shapes

Shadows are the describers of form and they come in an infinite variety of shapes, tones and colours. When you are studying the shapes of shadows, be prepared to discover the unexpected. Look at how they interplay with and around your subject and observe their subtleties and tones. Try to be aware of how shadows seem to make some edges merge or become lost altogether, while at other times they fall across objects and reveal form.

Without shadows our world would be a very flat and boring one, so concentrate upon shadows in your next painting and explore just how much they can transform your work.

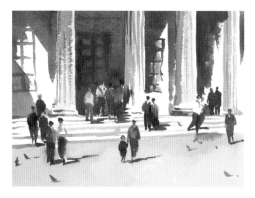

◄ **Outside the British Museum**
18 × 23 cm (7 × 9 in)
In this painting the shadow shapes play the most important role, describing not only the building and the people but also the pigeons.

 ▶ **Dark Riders**
18 × 23 cm (7 × 9 in)
Only small amounts of light fall on the subject here, leaving the children and donkeys to form a whole shadow shape. I allowed dark colours to merge in these shadows.

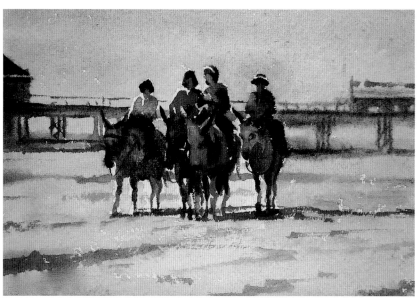

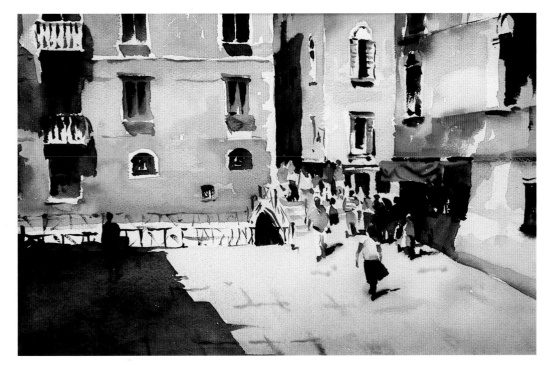

◀ Street in Venice
25 × 36 cm
(9¾ × 14¼ in)
Here the people
seem to get lost
and found in the
heavy shadows and
light areas of the
buildings. The figures
become part of the
scenery and it's
the shadow shapes
that dominate.

Shadow tones

To achieve a sense of reality, it is
important to make your shadows the
right tone. They often appear darker at
first than they really are, so let your eyes
adjust to them before deciding on their
correct tone. You may see reflected light
or colour in shadow areas, so try to
indicate these in your washes.

QUICK TIP

Try dropping other colours into
your shadow shapes while the
wash is still wet to vary the
temperatures in them. After all,
shadows are not always cold!

Cast shadows

Using cast shadows in a painting can give a heightened sense of three dimensions and support for the light areas. The direction of a cast shadow will throw other objects into relief and very often shadows will cast themselves into your picture space from outside.

Information from shadows

Study the direction of cast shadows and you will notice that they always appear opposite to your light source. This observation is vital to creating more form and giving a powerful three-dimensional look to your people. The length of the cast shadows will give your viewer the time of day; for example, the low sun of early morning and late evening will provide longer shadows cast from objects than at any other time.

If you are painting people in interiors, such as inside a church or a shopping mall, or under electric lights, cast shadows can become more complex because there is usually more than one light source. Pay attention to how your subject is being lit and then identify its cast shadow before painting, or you may confuse the viewer's eye.

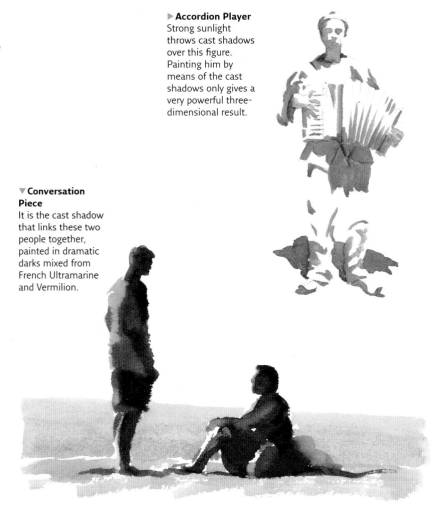

▶ **Accordion Player**
Strong sunlight throws cast shadows over this figure. Painting him by means of the cast shadows only gives a very powerful three-dimensional result.

▼ **Conversation Piece**
It is the cast shadow that links these two people together, painted in dramatic darks mixed from French Ultramarine and Vermilion.

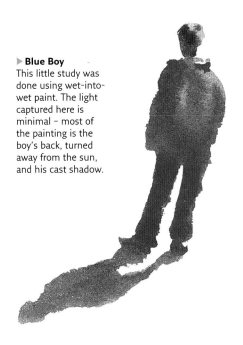

▶ Blue Boy
This little study was done using wet-into-wet paint. The light captured here is minimal – most of the painting is the boy's back, turned away from the sun, and his cast shadow.

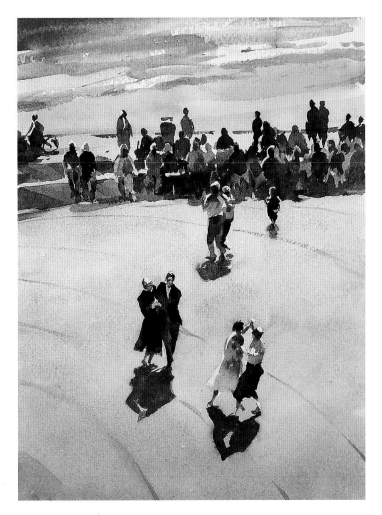

▶ Beach Tango
30.5 × 23 cm (12 × 9 in)
The cast shadows here catch the mood of the moment as dancers sway on Brighton Beach.

Counterchange

The way that shadows and other dark shapes interlock with the light in a painting is crucial to its success. Counterchange refers to the sequences between light and dark where one is set against another.

Backgrounds are important here, as well as textures and patterns; negative shapes play as large a part as positive ones. An extensive use of counterchange will eliminate the need for too much detail, as it provides an effective system of selection for what is really important in a painting.

On the next few pages are some examples of how counterchange can help you in painting people, and how the light that is trapped from the background comes into play in describing them.

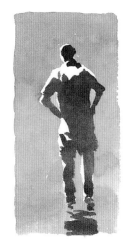

◄ Standing Figure
Two flat tones have been used here to counterchange the figure from its background, leaving the white of the paper to describe the light hitting it.

▲ Counterchanged Figure
Here, half the figure is painted dark against a light background and the other half is left white against a dark background.

◄ Figures on a Beach
The people were painted in first with a No. 8 brush. When they were dry, pale washes of French Ultramarine and Raw Sienna were used to trap the highlights for the counterchange effect.

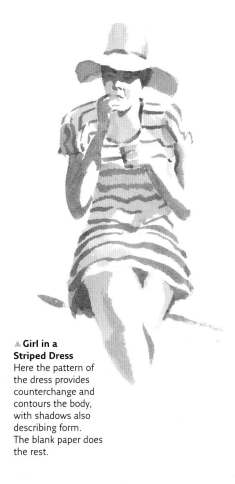

The Tourist 1
This quick tonal counterchange sketch was done in tones of grey using a No. 10 brush on 640 gsm (300 lb) Rough paper.

The Tourist 2
Washes of Indian Yellow, French Ultramarine and Vermilion glazed across the tonal sketch gave a colourful result.

Girl in a Striped Dress
Here the pattern of the dress provides counterchange and contours the body, with shadows also describing form. The blank paper does the rest.

QUICK OVERVIEW

☐ Look for shapes, tones and lost edges in shadows.

☐ Make sure all cast shadows appear opposite your light source.

☐ Set light against dark then vice versa to add interest in the form of counterchange.

Using counterchange

Using strong tones and colours in a picture results in a dramatic and colourful statement. Before beginning on the painting itself, make a small thumbnail sketch of the tonal values using Burnt Umber. Block in the darks first and then trap the white paper with half tones.

MATERIALS USED

2B pencil
No. 8, No. 10 and
 No. 20 round
 brushes
Arches 640 gsm
 (300 lb) Not paper
Burnt Umber
Coeruleum
French Ultramarine
Permanent Rose
Raw Sienna
Vermilion

1 Referring to your thumbnail sketch, lightly draw in the general shapes of the riders with your 2B pencil, making sure to indicate where the white paper should be left. Then, with the No. 20 brush, lay down a background wash of Raw Sienna, French Ultramarine and Vermilion, surrounding the white areas. Use pale Vermilion for the foreground of this wash. Allow the washes to dry.

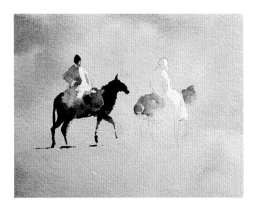

2 Using the No. 8 brush and a dark mix of French Ultramarine and Burnt Umber, start with the left-hand rider's hat then move down to the face, using Raw Sienna with Vermilion for the flesh tone. Wash in some French Ultramarine for the shadows on the clothing, varying this with a drop of Permanent Rose. Then put in the darks for the horse by brushing in strong mixes of Burnt Umber and French Ultramarine.

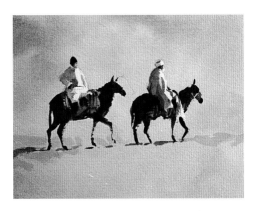

3 Paint the second figure but this time use a pale mix of French Ultramarine and Raw Sienna for the clothing and blanket. Using the tip of the No. 8 brush, put in the stripes on both blankets with stronger mixes of French Ultramarine. Finish this stage by painting some of the cast shadows that fall on the ground, using dark mixes of Burnt Umber.

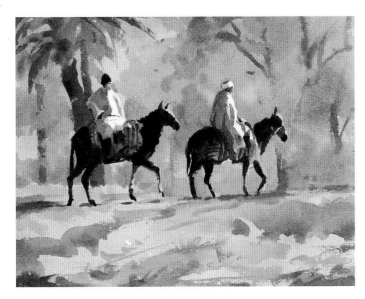

4 Start the background from the top left, loading your No. 10 brush with mixes of Raw Sienna and Coeruleum for the palm trees. Vary these washes as much as possible, adding Burnt Umber for the trunks. Working to the right, drop Coeruleum and Raw Sienna into one another on the paper to create merging. As you paint around the figures, make sure you capture some light on the heads of the animals. Finish by using similar washes in the foreground but with more Burnt Umber to create texture and movement.

◀ **Light in the Oasis**
18 × 23 cm (7 × 9 in)

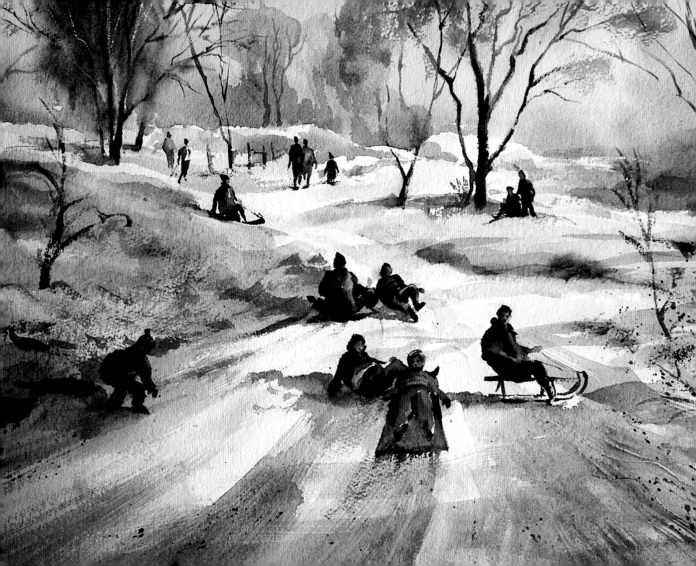

BACKGROUNDS

When I am painting, I very often prepare backgrounds before putting my people into them – a little like creating the stage setting before the actors begin performing. The reason for doing this is that laying preliminary background washes can give a sense of space and scale and therefore make the task a lot easier.

In this chapter, you will discover how to lay in backgrounds to give you a head start on your pictures. This kind of preparation can be very exciting – letting colours flood into one another in broad patches to create more expression and feeling right from the beginning is a liberating procedure and sets the mood for a loose 30-minute painting.

◀ **Snow at Crickley Hill**
33 × 50 cm (13 × 19¾ in)
Here I created the setting for my figures first, using large washes of neutralized colour for the background. I put on further glazes after the people had been painted in.

Backwashes

Laying down a backwash of colours to create an atmospheric space on which to paint is a mainstay in the construction of a successful watercolour; it will allow you to leave colourful, lighter areas from successive washes as well as giving you a general setting or mood.

Wet washes

This is where your No. 20 round brush will come in handy, as a large flow of paint is vital to gaining the transparency of a glowing wash. Rather than mixing your colours in the palette, drop them on the paper wet-into-wet and then allow them to merge together naturally by tilting the paper at different angles.

This will give a clear and fresh look to your backwashes.

You may feel that the washes are out of control at first, but this approach is not as unpredictable as it sounds. Limit yourself to two or three colours at first and work quickly and confidently. Let the backwash dry thoroughly before putting in any subject matter.

▶ **Sun Seekers**
18 × 30 cm (7 × 11¾ in)
Here a backwash was prepared from washes of French Ultramarine and Raw Sienna, this time leaving white spaces from the paper to represent the waves. People were added in groups, as little more than silhouettes.

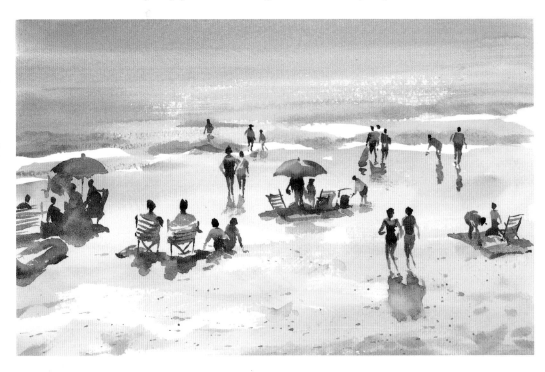

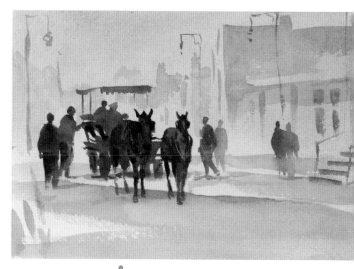

▲ **The Local Bus**
23 × 32.5 cm
(9 × 12¾ in)
In this quick painting
silhouettes have
been used over a
backwash of French
Ultramarine, Cobalt
Blue and Raw
Sienna. The people
were put in using
Cobalt Blue and
Burnt Sienna mixes.

▲ **Russian Scene**
22 × 15 cm (8¾ × 6 in)
This very simple
backwash consisted
of just two colours –

Cobalt Blue and Raw
Sienna. The wash
was left to dry before
any subject matter
was put in.

┃ QUICK TIP

Using mainly blues and yellows
in your first backwashes will
produce pleasing atmospheric
results. Different combinations
will give you a range of effects.

Negative shapes

The term 'negative shapes' refers to the spaces that appear in between and around the objects you are painting. Identifying these shapes becomes easier the more you look for them. For instance, the space between a person's legs could be regarded as a negative one; so too the hole that is created between the arm and the body when someone stands hand on hip.

Spotting these areas and painting them in can be fun and can give the painting a different and interesting look. Sometimes negative spaces can be simpler than positive ones, bringing much more accuracy to the underlying drawing. If you start your painting by filling in these shapes you will be able to determine what to select next.

It may seem odd to concentrate on painting negative things, but as you do so you will be aware of the positive objects beginning to emerge from the space.

▶ **Negative shapes**
This illustrates the principle of negative painting. The spaces around the object and through it are as important as the object itself.

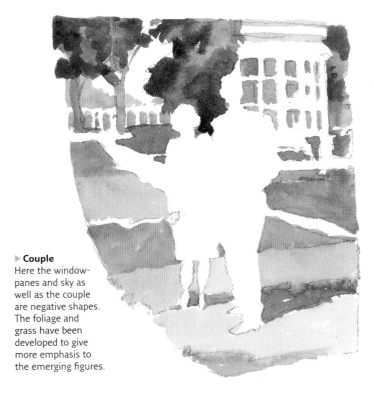

▶ **Couple**
Here the window-panes and sky as well as the couple are negative shapes. The foliage and grass have been developed to give more emphasis to the emerging figures.

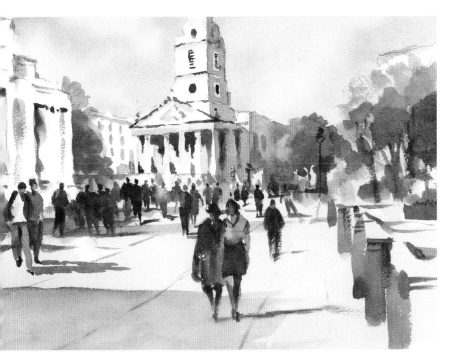

▲ Outside the National Gallery, London

21 × 29 cm (8¼ × 11½ in)

Here, concentrating upon the sky and the shadows as negative shapes has brought the white of the buildings forward. These were painted first and then the people were placed in front of them.

QUICK TIP

When looking at your subject, try squinting your eyes. This will help you to distinguish the negative shapes without getting confused by the detail.

QUICK OVERVIEW

☐ Begin your paintings with loose, wet-into-wet washes, using two or three colours at first.

☐ Dark backgrounds will add atmosphere and throw your figures into relief.

☐ Filling in negative shapes will help to make your positive ones more accurate.

Dramatic backgrounds

Emphasizing tone or colour in a background can lead to dramatic effects. Sometimes it's necessary to achieve a rich dark backwash to throw your figures into relief, or strong colour washes to accentuate mood and atmosphere. This will need a little practice, as it requires a bolder attitude to backgrounds and more accurate rendering with the brushes.

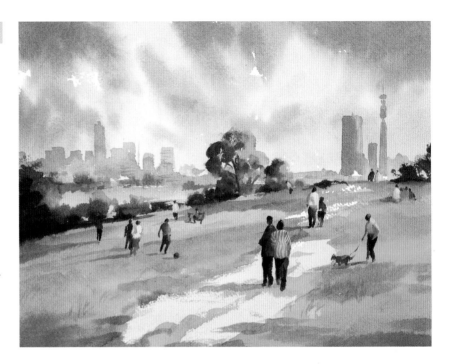

▲ Parliament Hill
24.5 × 32 cm
(9½ × 12½ in)
In this painting the figures were added in after the landscape was complete. I mixed Chinese White and Lamp Black with other colours to create the lights and darks respectively.

Using opaque colours

You will find opaque colours such as Chinese White and Naples Yellow very useful in this project as they will sit on top of darker washes where it is not possible to paint around light shapes. They can also be mixed with other colours to provide more body or opacity.

Conversely, don't be scared to use large, open washes of Lamp Black to create tonal drama or to add to your other colours in order to darken them. Cadmium colours such as orange will cover and brighten over a dark wash.

Many students of watercolour regard using opaque paint as a form of cheating, but having the ability to go either way with lights and darks gives more flexibility. For this project, explore this versatility in your backgrounds.

Adding colour

Try to use colour in both light and dark areas in your backgrounds. Light areas usually reveal their colours in a more obvious way but the dark ones are tricky, requiring more conscious observation. Warm colours in light areas will make them come forward and cool colours will make them recede; the same is true in dark passages. Dark tones can be made very effective by adding colour into them.

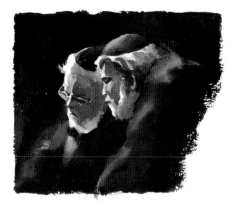

◀ **A Word in your Ear**
15.5 × 18 cm (16¼ × 7 in)
Here the faces were painted first very carefully using a No. 8 brush then surrounded by a wash of Lamp Black mixed with Cobalt Blue to capture the highlights on the clothing. No white was used.

▶ **Down by the Riverside**
11 × 23.5 cm (4¼ × 9¼ in)
This little painting started life with a rich backwash of French Ultramarine, Permanent Mauve, Coeruleum and Raw and Burnt Sienna. The people were put in using Chinese White for the clothing and Naples Yellow to give body to the flesh colours.

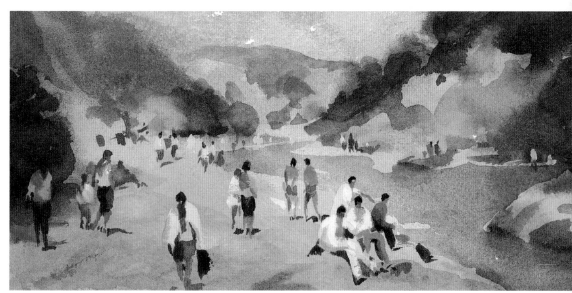

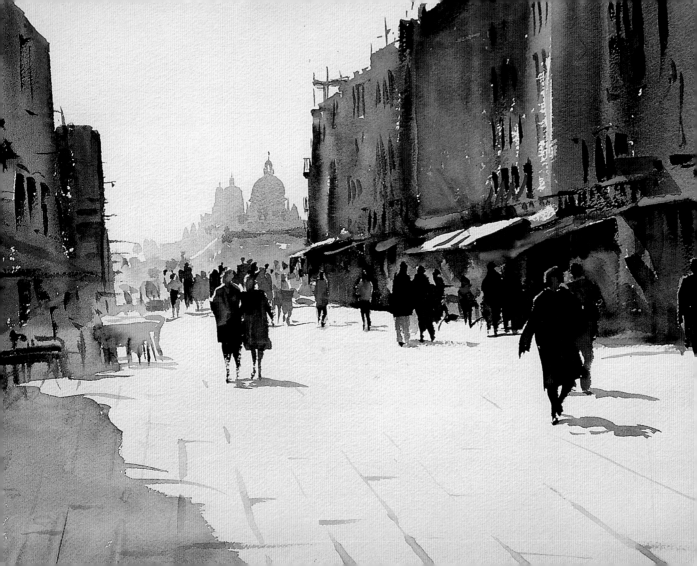

PEOPLE IN GROUPS

Painting people in groups or pairs rather than as single figures may seem like a daunting task at first. However, thinking of a group of people as one shape, rather than a collection made up of single objects to be painted one at a time, will make your task considerably less complex and will add cohesion to your pictures.

Linking groups of people can be done in a number of ways, such as overlapping or lost and found edges. Shapes, colours and tones can intermingle in a group and create a greater sense of intimacy between them. With this approach to multi-peopled pictures you will discover how to paint them fluidly and quickly in just 30 minutes.

◀ **Via Garibaldi, Venice**
33 × 50 cm (13 × 19¾ in)
In this street scene figures huddle in pairs and groups. Some even appear to merge with the shadows and shops.

Interaction

When you are people-watching, look for the ways in which they interact with one another, sometimes taking on the form of one shape rather than many. Practising this observation in everyday life will pay off in your painting, as it will help you to determine quickly how individual shapes link together. They may interlock by means of a shadow, for example, or by one member of the group overlapping others; sometimes there may be a colour that recurs throughout a group. Tying your figures together in this way will make the groupings more cohesive and readable in the picture.

◄ Beach Towels
The way the towels touch and the surrounding colour of the sand are the obvious interaction here, but the echoing patterns also form a connection.

▼ Red Dress
The background group of dark-clothed figures makes the girl in the red dress stand out, but because she overlaps them she is also linked to them.

► Company of Three
Although the boy in the blue hat is the focal point, the grey shadow links all the group together.

Backgrounds and props
Of course backgrounds can be a great unifying factor in a painting, broadly joining elements together. In your foregrounds, objects such as a park bench will connect all those who are seated upon it, as will a shared towel on a beach. There are as many devices to perform this linking function as you can think of. Keep your sketches small and simple and be guided by your intuitive ideas about composition.

▼ **Park Bench**
24 × 41 cm (9½ × 16 in)
The bench itself joins the people together here, while the backdrop of foliage is an extra device to help this interaction.

▲ **Market Men**
The whole of the background acts as a linking mechanism here and allows the three men to join together as one group.

QUICK TIP

A simple passage of light or dark will often help to link your figures together as well as creating a meaningful composition.

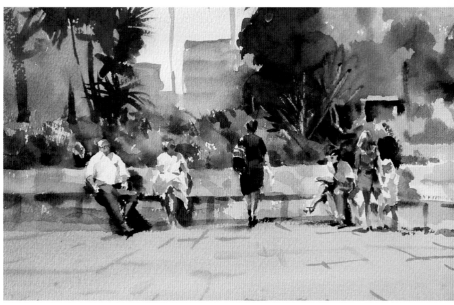

Small-scale groups

Small marks can be very powerful where groups of figures appear in larger views or panoramas. Keeping these marks simple and creating them with the first stroke of the brush takes a bit of practice.

Gauging how small or large the mark needs to be to create a figure seen from a distance is a question of good judgment and a skilful hand. Make sure that your No. 8 brush comes to a fine tip before you begin practising. Try to abbreviate the type of figure required, using a single mark with the brush – dots, dashes and triangular slabs are the shorthand required here. Quick reaction and simple mark-making goes a long way in building small groups of people from these abstract blobs of colour.

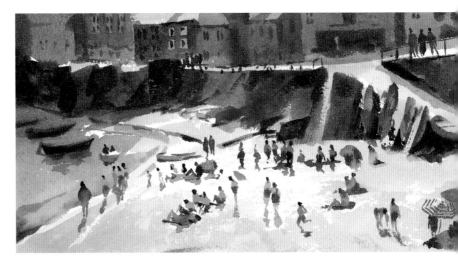

▲ **Cornish Beach**
14.5 × 29 cm
(5¾ × 11½ in)
This panoramic scene was painted in first to act as a backdrop for practice in painting miniature people. The figures are abbreviated to mere dots and dashes.

▶ **Beside the Sea**
8 × 12 cm (3¾ × 4¾ in)
Backwashes of Coeruleum and Raw Sienna were put down first for this simple beach scene.

Learning a visual language

Painting in very small areas is a good way to practise this discipline; in time you will build a visual language that you can develop as you paint. In this way of painting one mark is as good as another, so don't be tempted to go back over shapes and tidy up. It's how they all look together at the end that counts.

Mask off some small rectangles of 640 gsm (300 lb) paper with your masking tape – they should not be more than 12 x 7.5 cm (4¾ x 3¼ in). This will force you to make smaller marks and produce miniature paintings easily achievable in 30 minutes.

Lay down some pale washes of colour and let them dry, then use the tip of a No. 8 brush to paint in your people. Add Naples Yellow to your flesh colours as this will give more opacity to the paint. Remember that suggestion will make for a livelier painting than detail.

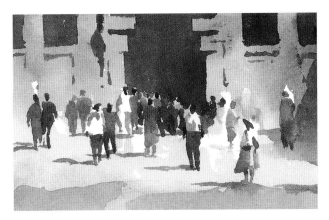

◀ **Egyptian Temple**
8 × 12 cm (3¼ × 4¾ in)
I left random whites from the paper in my backwash which I used to form some of the people. The background darks were made from Cobalt Blue and Burnt Umber.

▶ **St Mark's Basilica, Venice**
8 × 12 cm (3¼ × 4¾ in)
I painted my people in first and then concentrated on the background, bringing St Mark's Basilica forward by using a wash of Cobalt Blue in the sky.

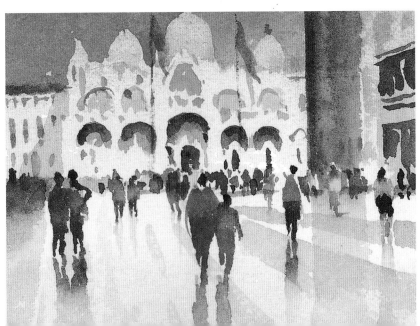

Crowd scenes

Now that you have worked on your small groups of people and found linking mechanisms to tie them together you should be ready for your first crowd scene.

The overall size of your picture will determine the time in which you can accomplish it. Although it's not impossible to paint crowd scenes in miniature it does require a great deal of patience, so a larger format of about 23 x 18 cm (9 x 7 in) is a better choice – any larger may take you longer than 30 minutes.

Work loosely and suggest the people rather than painting one at a time. Try to see the whole mass of figures as one shape consisting of abbreviated marks and colours and apply the paint in rapid rhythmic movements, making decisions as you go.

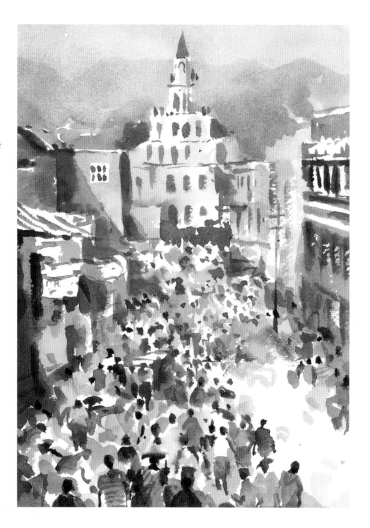

▶ **Caribbean Market**
23 × 18cm (9 × 7 in)
This street market scene is buzzing with people, forming one mass made from dots and dashes of colour. Part of it has been left unfinished so you can see how I achieved this.

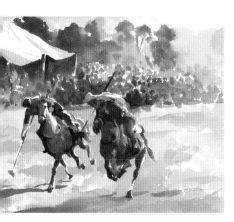

◀ **The Last Chukka**
20 × 26.5 cm (8 × 10½ in)
Sporting events are
always great to paint
because people are
in action. Here
the crowd scene
behind the players
acts as a foil to the
main interest.

▼ **Palazzo Vecchio**
19 × 28 cm (7½ × 11 in)
First I painted a wash
of Raw Sienna and a
purple made from
French Ultramarine
and Permanent Rose
to capture the light

falling on the palazzo.
The two forward
figures were put in
with strong darks and
then the crowds
behind with short
stabbing strokes from
the No. 8 brush.

Finding the action

Crowd scenes often accompany some
kind of action such as a sporting event or
festival. Funfairs and carnivals are great
places to pick up reference photographs
for painting in the studio later on, so take
a camera with you when you go to them
and keep an eye out for scenes you may
want to paint.

QUICK TIP

When you are painting a crowd
scene, start with the heads first,
then use shapes and colours to
indicate overlapping bodies.

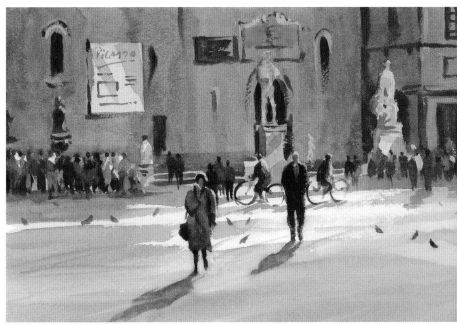

Impressionist techniques

In the 19th century, the Impressionists sought to capture the fleeting moment of light and colour as it conveys a scene, much like the camera does. Their use of paint was revolutionary at the time; short stabbing marks were often collected together on a canvas to portray a larger subject. Many of the brushstrokes were left undisturbed, making their techniques direct and unblended.

The Impressionists' aim was to allow the viewer's eye 'into the picture' and express a mood or feeling quite distinct from what had gone before. Everyday subjects were used for the first time and often painted on location, *en plein air*. Their paintings were a testament to modern life and set the stage for all future artists to move forward.

Reactive brushwork

Instinctive, loose brushwork will bring an impressionistic feel to your scenes. You can either work from life, including people in ordinary everyday situations, or from photographs that have caught a fleeting moment. Let the brush roam freely, keeping your eye more on the subject than the paper, and use simple, direct brushstrokes.

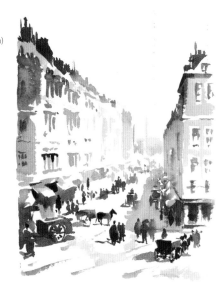

▶ **Impression**
22 × 16.5 cm (8¾ × 6½ in)
I went back to monochromatic colour to create this scene, using an old photograph taken in Paris in about 1855. I let the brush react to what my eye saw and a quick, impressionistic painting was born.

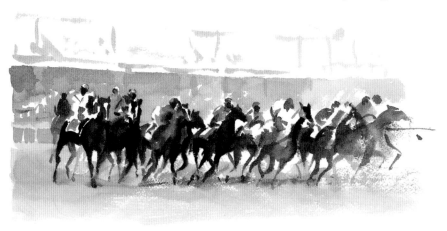

▼ **The Race**
14 × 27 cm (5½ × 10½ in)
Single strokes of a No. 8 brush have been used here to create the movement of the race. I kept the brushstrokes direct and didn't attempt any blending.

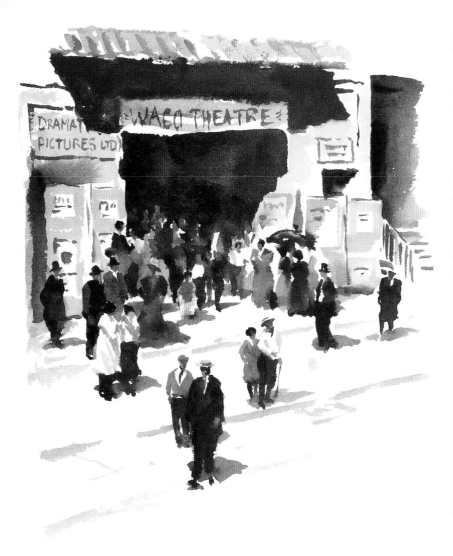

Use a No. 8 brush and keep your brushmarks direct, allowing them to collect together and mingle in the viewer's eye.

◀ **Waco Theatre**
21.5 × 17.5 cm
(8½ × 6¾ in)
Again an old black and white photograph was the inspiration, this time for an everyday scene of people outside a theatre. Although this looks like a complicated scene, half the paper has been left white.

QUICK OVERVIEW

☐ Link your people with colour, overlapping shapes, shadows, patterns or shared objects.

☐ Use abbreviated, abstract marks for groups of figures in the larger scene.

☐ Experiment with Impressionist techniques of stabbing brushstrokes.

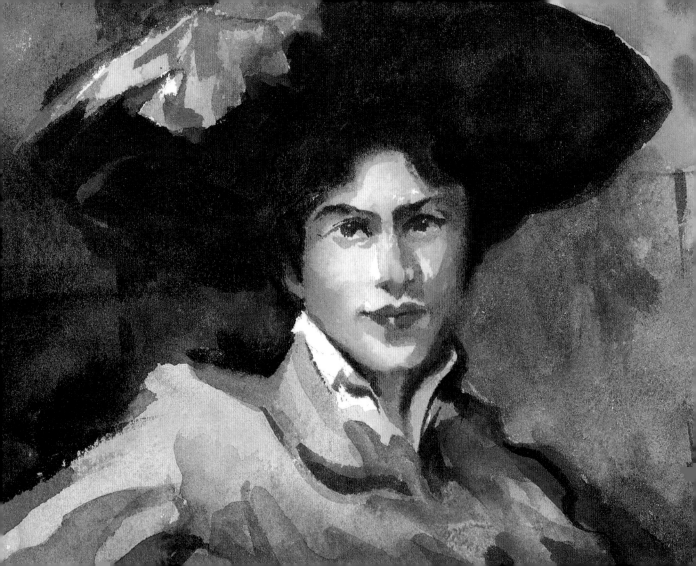

PORTRAITS

From the pharaohs to the present day, we humans have always been obsessed with representations of our own likeness. For painters, though, portraiture is sadly in decline, since it has largely been taken over by photography. Nevertheless, it still remains a fascinating testament to the artist's skill and perception.

Watercolour is the supreme sketching medium and its expressiveness makes it ideal for the portrait painter, whether for the briefest indication of someone's likeness or for a more developed portrait. Even in 30 minutes, working fluidly and loosely, you will be able to produce recognizable portraits you can be proud of.

◀ **Fancy Dress**
14 × 21 cm (5½ × 8¼ in)
I worked wet-into-wet on this tiny portrait painting, putting in the darks at full strength immediately. The features were the last to go in.

Achieving a likeness

Making a portrait a recognizable representation of someone is of course essential. Where you place the features in relationship to each other, and their relative sizes, dictate whether you will be successful in this or not.

There are many theories on how to get a likeness in portraiture. I mostly use the simple device of an imaginary cross when placing features on a head. If you judge the distances from this with accuracy a likeness will appear even without an overall outline, and you will find it especially helpful when time is of the essence.

Using a cross

With a frontal view of your subject's face, visualize the cross with the upright from the top of the head to the chin and the crossbar from ear to ear, through the eyebrows. Other divisions for the base of the nose and lips can be made afterwards.

Things are less straightforward when the angle of the head changes, but to begin with, concentrate on frontal views with this imaginary cross.

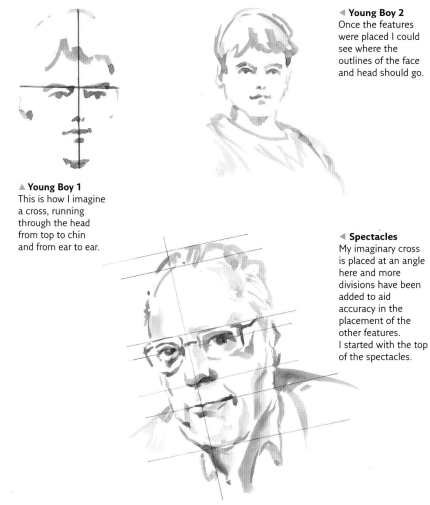

◀ **Young Boy 1**
This is how I imagine a cross, running through the head from top to chin and from ear to ear.

◀ **Young Boy 2**
Once the features were placed I could see where the outlines of the face and head should go.

◀ **Spectacles**
My imaginary cross is placed at an angle here and more divisions have been added to aid accuracy in the placement of the other features. I started with the top of the spectacles.

Profiles

You can apply the same geometric approach to profiles. They may seem simpler at first because you are apparently dealing with only half of the information, but mistakes are easily made if you don't concentrate.

You will find it very helpful to construct a profile from a worked-up pencil sketch to give yourself as much information as possible before you paint. Use a 2B pencil on cartridge paper for this and remove lines with a putty eraser if they become too confusing.

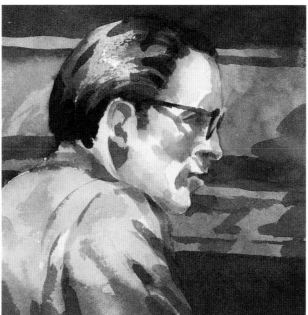

◄ **Profile**
14.5 × 14.5 cm
(5¾ × 5¾ in)
I put down a wash over the whole picture first, using my flesh colours of Indian Yellow, Coeruleum and Vermilion. I worked the shadows of the face and then put in my darks last, merging them into the hair and jacket.

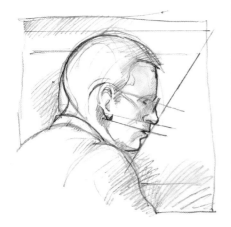

◄ **Profile sketch**
I worked at this pencil sketch until I was sure I had the correct divisions on my imaginary cross.

│ QUICK TIP

The hairline is quite particular to each individual and is therefore important to the likeness of your subject. Taking time to indicate this will pay off.

The head

Generally speaking, the shape of a human head is oval, but this can vary greatly from person to person. Observation is the skill you need in getting the right oval shape for your particular subject. Look for slight indentations or angles to precisely determine the type of head you're after, and don't forget that the width and length of the neck can also be particularly recognizable features of your subject.

A good way to start is by lightly spinning the pencil around on the paper to get a general shape. This produces numerous lines which you can choose from later as the sketch develops. Follow the same procedure when you are painting your general shape, using a No. 10 brush loaded with colour. When the wash is dry, go in with a No. 8 brush to develop the features, visualizing how they look on your imaginary cross. If your oval or balloon-like shapes of colour are not as accurate as you would like them to be, don't worry – they can be changed or developed later on.

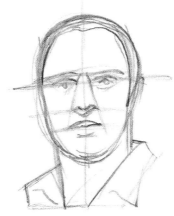

◀ This drawing shows my oval shape and imaginary cross to place the features on. I have included the neck and collar of a shirt to give the head more form.

▼ These two illustrations show the oval shape I put down in paint with a No. 10 brush and the initial developments of the features. I made corrections to the overall shape as I went along.

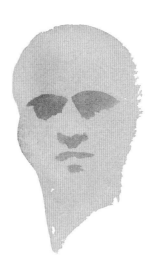

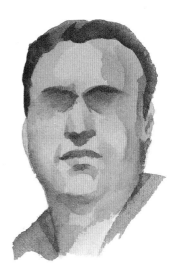

Line and wash

Once you have become familiar with practising the shape of the head in paint, it's time to move on to line and wash; a continuous line with washes of colour can provide a looser look and get a flow of paint going onto the paper.

Make your initial line drawings on cartridge paper, no bigger than 13 cm (5 in) in height. Keep the lines simple, with no erasing. Try to get round the whole subject with a continuous flow of line and don't go back to correct mistakes or you will ruin the look.

After you have made two or three line sketches, start putting in some simple washes of colour, making as much use of the white paper as you can.

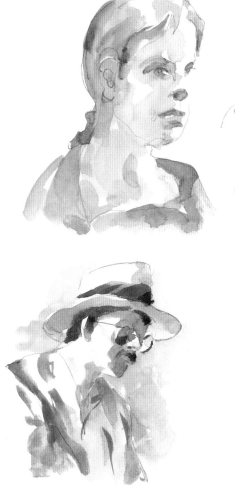

▶ **Line and wash sketches**
In these colour sketches I have used the white of the paper to represent the light that hits the subject. They make basic informal studies for portraits.

QUICK TIP

Cleaning out your brush between washes and removing excess water on a soft rag will give your colours a fresher appearance on the cartridge paper.

The features

It is the features that provide the expression in a painted portrait, so make a habit of continually drawing and painting them, both separately and in groups, looking at them from different angles. My early sketchbooks looked something like police identity kits, with a variety of differently shaped eyes, noses and lips. Miniature studies of these can be fun and need not take up a lot of time.

Try to give features a soft expression and avoid hard lines around eyes and lips. Suggestion is all that is required sometimes. Use lost and found edges to make the features merge where they need to, such as at the corners of the mouth, where they soften into the cheek, or underneath the eyes, where you will see delicate shadows.

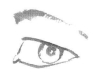

◀ Giving the eyes a slight angle makes them appear more three-dimensional. This eye was started with simple lines from a No. 8 brush then developed further with shadows and tones using washes of Burnt Umber.

▶ The mouth, nose and ears were treated in the same way. Noses are difficult from the front view as they have no hard line to tie them in with the other features.

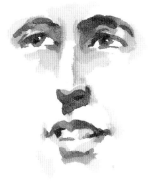

▶ Putting the features together in some form of expression, making as much use as possible of shadows and indentations, is good practice.

▍QUICK TIP

Cast shadows from features are particularly expressive and will often help you to create an accurate likeness if they are placed well.

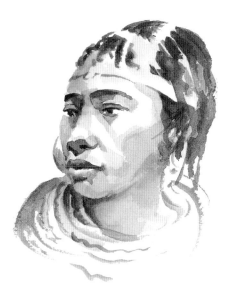

◄ African Girl
Here the features were painted first and the planes of the face worked outwards from these to form the whole head.

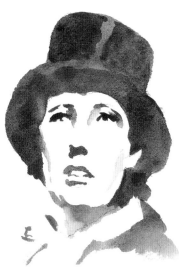

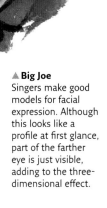

Angles and curves

The spaces in between the features are important as well. The angles and curves here are what we know as the planes of the face: the forehead, cheekbones, chin and so forth all need to be considered when painting a portrait.

Try studying your own face in a mirror and measuring the distances between your features as you draw yourself. After all, artists make their own best and most accessible models.

◄ Top Hat
The hat encloses all the features in one shape, providing a foil for the cheekbones and part of an ear. Accurate placing of features will give characteristic expressions.

▲ Big Joe
Singers make good models for facial expression. Although this looks like a profile at first glance, part of the farther eye is just visible, adding to the three-dimensional effect.

Putting it all together

You should now be keen to embark on a complete portrait, but remember that making a plan and doing some practice first will certainly lead to a better result than rushing straight ahead.

Start by practising the individual features of your portrait and how they fit together. Next, make a simple drawing of the head with your 2B pencil, indicating the main outline and then lightly sketching in the features. Start painting only when you are sure that the features are placed correctly.

Developing your portraits

Mastery in the art of portraiture requires observation and a skilled hand, so try to paint every day, even for just 30 minutes, to keep your inspiration alive and develop your expertise.

Failures are inevitable when you are painting portraits in watercolour, so don't be disheartened by them; instead, regard them as opportunities to help you go forward. In watercolour it is the way that colours merge and cover the surface of the paper in new and unconventional ways that excites. Exploration goes with this, and it applies as much to portraiture as to any other subject you will paint.

◀ **The Kenyan**
24 × 16 cm (9½ × 6¼ in)
I wanted to explore the colorations in the skin, using Cobalt Blue and Coeruleum to cool them down. I used abbreviated impressionistic marks for the jewellery to make the task less complex.

◀ Darlas
21 × 17 cm (8¼ × 6¾ in)
I used Permanent Rose with some Chinese White to create the pinks in this portrait. Most of the painting went in the top third of the composition, leaving plenty of white paper for the T-shirt.

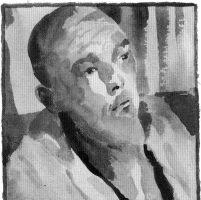

◀ Portrait Study
This was a quick compositional sketch but it turned out as I wanted it to, giving the features brief but accurate expression.

Making a portrait

In this portrait of a saxophonist, the starting point is a continuous line drawing of the head and shoulders to capture the pose before the features are put in. Next come large washes of colour on the figure and background to develop the framework before adding the final details.

MATERIALS USED
2B pencil
No. 8, No. 10 and
 No. 20 round
 brushes
Arches 640 gsm
 (300 lb) Not paper
Burnt Umber
Cobalt Blue
Coeruleum
Lamp Black
Raw Sienna
Vermilion

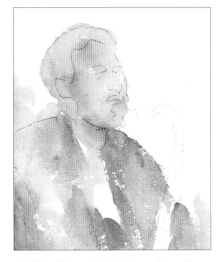

1 With a 2B pencil, lightly draw the outlines, using a continuous line on the white paper. Don't erase unwanted lines. Using a No. 20 brush, begin washing in pale tints of Vermilion, Raw Sienna and Coeruleum to the face, letting them merge together. Continue with a wash of Cobalt Blue on the jacket, merging it with pale washes of Lamp Black and Burnt Umber and allowing some to encroach on the background. Allow this stage to dry.

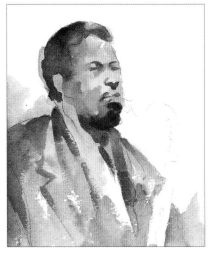

2 Using your No. 10 brush, develop the hair with washes of Lamp Black and Burnt Umber. Run these into the forehead, adding a mix of Vermilion and Raw Sienna. Use more Coeruleum for the beard and moustache, bringing in Lamp Black to accentuate the mouth and chin area. Make a mix of Burnt Umber and Vermilion in the palette and develop the facial features, painting in the cast shadows under the nose and eyes. Then start on the jacket, using the same mix.

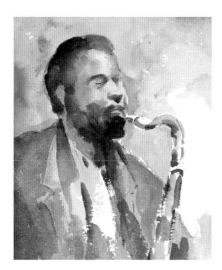

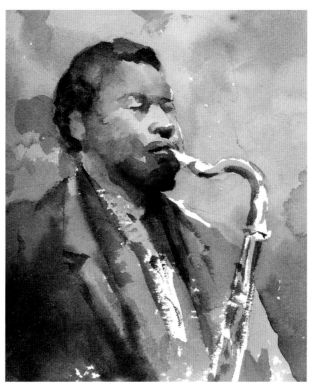

3 With a No. 8 brush, use strong dilutions of Raw Sienna for the saxophone, dropping in some Burnt Umber while they are wet and remembering to leave the white of the paper for highlights. Develop the jacket further with washes of Lamp Black, Cobalt Blue and Burnt Umber in unequal amounts. Next take the No. 20 brush and lay in the background with washes of Raw Sienna and Cobalt Blue, allowing them to merge on the paper and making sure you trap some white paper on the saxophone. Allow this stage to dry.

4 Using the tip of your No. 8 brush, strengthen the mouth with a wash of Lamp Black, then move on to the nose and eyes with this wash and develop them further. Mix up a cool grey from Lamp Black and Cobalt Blue then, with the No. 20 brush, put this into the jacket in the shadow areas to the left and under the chin. Use this same wash on the background on the right to throw the figure into relief. Finally, return to your No. 8 brush and put some details on the saxophone using a mix of Burnt Umber and Cobalt Blue.

FURTHER INFORMATION

Here are some organizations or resources that you might find useful to help you to develop your painting.

Art Magazines

The Artist, Caxton House, 63/65 High Street, Tenterden, Kent TN30 6BD; tel: 01580 763673
www.painters-online.co.uk
Artists & Illustrators, 26-30 Old Church Street, London SW3 5BY; tel: 020 7349 3150
www.artistsandillustrators.co.uk
International Artist, P. O. Box 4316, Braintree, Essex CM7 4QZ; tel: 01371 811345
www.artinthemaking.com
Leisure Painter, Caxton House, 63/65 High Street, Tenterden, Kent TN30 6BD; tel: 01580 763315
www.painters-online.co.uk

Art Materials

Daler-Rowney Ltd, P. O. Box 10, Bracknell, Berkshire RG12 8ST; tel: 01344 461000
www.daler-rowney.com
Jackson's Art Supplies Ltd, 1 Farleigh Place, London N16 7SX; tel: 0870 241 1849
www.jacksonsart.co.uk

T. N. Lawrence & Son Ltd, 208 Portland Road, Hove, West Sussex BN3 5QT; tel: 0845 644 3232 or 01273 260260
www.lawrence.co.uk
Winsor & Newton, Whitefriars Avenue, Wealdstone, Harrow, Middlesex HA3 5RH; tel: 020 8427 4343
www.winsornewton.com

Art Shows

Affordable Art Fair, The Affordable Art Fair Ltd, Unit 3 Heathmans Road, London SW6 4TJ; tel: 020 7371 8787
www.affordableartfair.co.uk
Art in Action, Waterperry House, Waterperry, Nr Wheatley, Oxfordshire OX33 1JZ; tel: 020 7381 3192 (for information)
www.artinaction.org.uk
Patchings Art, Craft & Design Festival, Patchings Art Centre, Patchings Farm, Oxton Road, Calverton, Nottinghamshire NG14 6NU; tel: 0115 965 3479
www.patchingsartcentre.co.uk

Art Societies

Royal Institute of Painters in Water Colours, Mall Galleries, 17 Carlton House Terrace, London SW1Y 5BD; tel: 020 7930 6844
www.mallgalleries.org.uk
Society for All Artists (SAA), P. O. Box 50, Newark, Nottinghamshire NG23 5GY; tel: 01949 844050
www.saa.co.uk

Bookclubs for Artists

Artists' Choice, P. O. Box 3, Huntingdon, Cambridgeshire PE28 0QX; tel: 01832 710201
www.artists-choice.co.uk
Painting for Pleasure, Brunel House, Newton Abbot, Devon TQ12 4BR; tel: 0870 4422033
www.readersunion.co.uk

Internet Resources

Art Museum Network: the official website of the world's leading art museums
www.amn.org
Artcourses: an easy way to find part-time classes, workshops and painting holidays in Britain and Europe
www.artcourses.co.uk

The Arts Guild: on-line bookclub
www.artsguild.co.uk
British Arts: useful information about all
art-related matters
www.britisharts.co.uk
British Library Net: comprehensive A-Z
resource including 24-hour virtual
museum/gallery
www.britishlibrary.net/museums.html
Galleries: the UK's largest-circulating
monthly art listings magazine
www.artefact.co.uk
Galleryonthenet: provides member artists
with gallery space on the internet
www.galleryonthenet.org.uk
Open College of the Arts: an open-access
college, offering home-study courses to
students worldwide
www.oca-uk.com
Painters Online: practical art site run by
The Artist's Publishing Company and
packed with information and inspiration
for all artists
www.painters-online.co.uk
Paul Talbot-Greaves: the author's website,
with details of his DVDs, painting courses
and a gallery of his paintings
www.talbot-greaves.co.uk

WWW Virtual Library: extensive
information on galleries worldwide
www.comlab.ox.ac.uk/archive/other/
museums/galleries.html

Videos
APV Films, 6 Alexandra Square,
Chipping Norton, Oxfordshire OX7 5HL;
tel: 01608 641798
www.apvfilms.com
Teaching Art, P. O. Box 50, Newark,
Nottinghamshire NG23 5GY;
tel: 01949 844050
www.teachingart.com
Town House Films, Norwich Business Park,
Whiting Road, Norwich NR4 6DN;
tel: 01603 281007
www.townhousefilms.co.uk

FURTHER READING
Why not have a look at other art
instruction titles from Collins?

Bellamy, David, *Developing Your
 Watercolours*
Blockley, Ann, *Watercolour Textures*
Crawshaw, Alwyn, *30-minute Sketching*

*Alwyn Crawshaw's Ultimate Painting
 Course*
*Alwyn Crawshaw's Watercolour Painting
 Course*
Learn to Paint Watercolours
Evans, Margaret, *30-minute Pastels*
French, Soraya, *30-minute Acrylics*
Jennings, Simon, *Collins Artist's Colour
 Manual*
 Collins Complete Artist's Manual
King, Ian, *Gem Watercolour Tips*
Peart, Fiona, *30-minute Watercolours*
Simmonds, Jackie, *Gem Sketching*
Soan, Hazel, *Gem 10-minute Watercolours*
 *Learn to Paint Light and Shade in
 Watercolour*
 Secrets of Watercolour Success
Talbot-Greaves, Paul, *30-minute
 Landscapes in Watercolour*
Trevena, Shirley, *Vibrant Watercolours*
Waugh, Trevor, *30-minute Flowers in
 Watercolour*
 Winning with Watercolour
Whitton, Judi, *Loosen up your Watercolours*

For further information about Collins
books visit our website:
www.collins.co.uk

INDEX